GHOSTS AND LEGENDS

OF

NEVADA'S HIGHWAY 50

GHOSTS AND LEGENDS OF NEVADA'S HIGHWAY 50

JANICE OBERDING

Haunted America

Published by Haunted America
A Division of The History Press
Charleston, SC
www.historypress.com

Cover photo by Bill Oberding.

First published 2018

Manufactured in the United States

ISBN 9781467139441

Library of Congress Control Number: 2018942445

CONTENTS

FOREWORD

Writing a foreword is a different role than I am used to performing. I'm the guy who does the photography. And the driving. I do most of the driving while we're on a book writing adventure. I am honored to write the foreword for this book and, yes, a bit intimidated as well. Janice and I have been married a long time. We've taken many treks across Nevada; one of our favorites is the "Loneliest Road," Highway 50. I still laugh at the memory of an early trip to Ely. We'd just purchased a new Buick, a beautiful and road-worthy car. But not so worthy for off-road, which is what we did. Janice wanted to see the Ward Charcoal Ovens, located on another lonely road south of Ely. The road was not paved and full of ruts and potholes. We did it, with no problems. We were lucky, I suppose.

Before retiring from the University of Nevada–Reno, I wasn't always able to go ghost hunting and traveling with Janice. She would go first without me, and we would return later for photographs and any final interviews she might need.

This book was especially fun because it is about an area of Nevada that is filled with history and natural wonder. But it sometimes gets overlooked, and it shouldn't. While Janice worked on this book, we met some interesting and unique individuals—a lot of people throughout the little towns along the loneliest road, and every one of them was friendly and happy to share their knowledge of their town.

If you have an interest in Nevada's history and ghosts, you will no doubt appreciate this book. Janice put a lot of hard work into it, I can tell you that.

Although I have taken a slew of photos of this area of Nevada over the years, many of the photos in the book are recent. When Janice presented the idea for this book, she knew that we had the photographs. But there was a problem: many of our photos were taken with an early model Sony Mavica with less than 1 megapixel of resolution. That was great for the year 2000, not so much now. So, trips were planned.

In all, we took three special trips, ghost hunting, gathering information and reshooting photos. Along the way, we met some new friends as well as rekindled old friendships. Not much has changed in the old towns along Highway 50 since our first trip several years ago. It's still a lonely road, unless you get caught behind heavy-duty mining equipment being transported from one location to another—which of course we did, and then we were traveling at Pony Express speed. While we were complaining about slow going, we stopped ourselves and thought about the young Pony Express riders who traveled this same route at what they saw as breakneck speed.

Like all of Janice's books, this book is a tribute to Nevada, the state she loves. It's a tribute to the small out-of-the-way towns and unique people with which Nevada abounds. We always have favorites. One of my favorite places that we visited again was the Nevada Northern Railway Museum in Ely. There we met some fascinating and friendly people. Being cat lovers, we especially enjoyed meeting Shop Kitty, our nickname for a little orange and white kitty that has taken up residence in the engine house building.

In her writing, Janice has a way of making you feel that you are experiencing what we experienced. I say that not because she is my wife, but because it is the truth. Those of you who are fans and readers of her books already know this. So, take a ride with us across the Loneliest Road in America. Enjoy!

BILL OBERDING,
photographer, researcher, technical advisor, driver and,
most importantly, husband

ACKNOWLEDGEMENTS

Writing means sharing. It's part of the human condition to want to share things—thoughts, ideas, opinions.
—Paulo Coelho

This is so true. And in writing a book such as this, the writer doesn't do it alone. Sure I may sit here at my cluttered desk all alone, tapping out words that will become sentences, paragraphs and ultimately a book. But I couldn't do it without the help of a lot of people. First, I would like to acknowledge my husband, Bill. Without his love and encouragement over the years, I might not have ever written one sentence, let alone a book. Bill's photography is seen throughout this book. And I thank him immensely for everything and especially for this book's sweet foreword. Thanks go to my mother, Bonnie Harper, who has offered helpful suggestions whenever I've asked, "So what do you think, Mama?" Thank you to my sister, Diane, who the world knows as "Glenda Grulke." I can always count on Diane to check and double-check me.

As always, there are the people I met along the way. Special thanks go to the wonderful people of Eureka, especially to Kim Hicks and Rich McKay, who took time from their busy schedules to show us their town, and for the ghost hunting. And thank you to J.J. Goicoechea, chairman of the Board of Eureka County Commissioners, for the warm welcome and your firsthand Eureka knowledge you shared with us. Thanks to Adam Bogart and Sonia Bogart of Eureka Paranormal, who answered my questions about the

paranormal aspects of Eureka. Thanks to Petra Brandt for an interesting investigation of the Eureka Opera House. To Eric and Kurt at the Nevada Northern Railway Museum, thank you for kindness when Bill and I visited the museum and for your willingness to show us around and answer our endless questions.

Thank you, Gail Utter, for your kindness in showing us around at the old Lander County Courthouse in Austin. You gave me a better understanding of the building and of the lynching that had taken place there. I also wish to thank Angela of media relations at Nevada Tourism for helping me and for permitting me to use the beautiful photograph of the Ward Charcoal Ovens in this book.

Thank you, Jeff and Bruce of RASS, who went to Ely looking for ghosts. Special thanks to the staff at the Sundown Lodge in Eureka for your above-and-beyond kindness to Bill and me.

Thank you to all the fine people at Arcadia Publishing and The History Press, especially Laurie Krill. Without you seeing the possibility of my book idea, it would not have come into being. And last but certainly never least, thank you, dear reader. Without you, there would be no point in writing.

INTRODUCTION

mazing is a word that's been overused in the last few years. And yet, when you're talking about Highway 50, the "Loneliest Road in America," it's the perfect word to describe it. Along with my husband, Bill, I have traveled the highway more times than I can count. There is always something to see in the desert. The way the early morning sunset strikes the mountains and how a group of clouds cast deep, dark surreal shadows across the landscape—these are but a few things to see and experience out in Nevada's desert on the Loneliest Road.

But what is a road without the communities it runs through? Bill and I have spent some time in every one of them, getting to know the places and the history. Each time we see something new, something we have missed or overlooked previously. We might be historians, collectors, ghost hunters and more, but we are first and foremost Nevadans and explorers. But there are other towns along Highway 50. They are the ghost towns, forgotten and crumbling under the weight of time and climate. Many of them are but a few miles from the Loneliest Road in this area of the vast Nevada desert.

Nevadans are comfortable with their wide-open spaces. Admittedly, the desert isn't for everyone. Hard as it may be for a Nevadan to understand, there are visitors who tend to look at the deserts that cover most of the state as monotonous and boring, a place to drive through *pronto* en route to somewhere else. But there is so much to see and explore in the desert, especially out on that 287-mile stretch of Highway 50 that crosses central

Nevada through Fernley, Eureka, Austin, Fallon and Ely. This is the Loneliest Road in America.

There's a story about how it earned that appellation. It begins with an article in the July 1986 issue of LIFE magazine. This particular issue was dedicated to the Statue of Liberty. There was also an article entitled "America the Most," about America's superlatives: the oldest, the bravest, the cutest and so on. Nevada's Highway 50 was awarded "Loneliest Road" status, and as evidence, the paragraph included a quote by an unnamed representative of the American Association of Automobiles: "It's totally empty. There are no points of interest. We don't recommend it. We warn all motorists not to drive there unless they're confident of their survival skills."

That quote garners chuckles from anyone who has driven the highway. They realize that the Loneliest Road in America is really the best way to see and explore Nevada. It's what Nevada is all about. It follows the route of the historic Lincoln Highway, built in 1926 to encourage motorists to get out, see the country and explore by driving across it. Long before that was the Pony Express route, which parallels Highway 50. Many of the old Pony Express stations are still out there—time-ravaged but testaments to the bravery of young men who raced to deliver the mail along this very same path.

LIFE magazine's unnamed source was shortsighted. He or she had failed to see the beauty or the history of Nevada's desert. This source also did not understand that one man's desolation is another's joy. The name stuck. More than thirty years have passed, and yes, the road is still lonely, although traffic has increased somewhat since that time.

There is no denying that most times during the day, you will cover a lot of asphalt on Highway 50 before you encounter another vehicle. It's just you and the road that stretches on and on and on—lonely to some, heaven to others. Turn up the stereo and reflect on all the history that surrounds you as you drive. Along with all that history are the ghosts that haunt some of the places here on the highway. History and ghosts—the two are forged together. One is not complete without the other.

It's a fact that Nevada can turn bad press to good (lemons to lemonade) faster than a desert storm can turn into a dangerous, life-threatening flash flood. Just as it did with the Extraterrestrial Highway to the south, the Nevada Commission on Tourism took LIFE's snarkiness in stride and came up with the "I survived the Loneliest Road in America" promotion. Travelers can buy T-shirts, bumper stickers and other souvenirs, as well as get their free US 50 passport stamped every fifty miles or so in the small towns along the highway: Eureka, Austin, Ely, Fernley and Fallon. Each of

these towns is worth a stop. Each one is Nevada, and yet each is a one-of-a-kind little spot along the Loneliest Road in America. Each town has its history, its legends and its ghosts.

Then there is the breathtaking scenery of Great Basin National Park, with its ancient bristlecone pines, believed to be some of the longest-living trees in existence, and the Lehman Caves. Yes, Highway 50 will take you there.

LIFE may not have been impressed with the starkness of Nevada's Highway 50. But *Road and Track* writers certainly were. In the June 2017 issue, this magazine featured an article entitled "The Loneliest Ferrari," for which two writers took a Ferrari GTC4Lusso on the Loneliest Road, starting in Ely. Complete with colorful photography and points of interest, the article is much kinder and more informative than that of *LIFE* magazine.

Fill up the gas tank, check the tires and the oil, lather on the sunscreen and prepare to be amazed as you traverse the Loneliest Road in America, as well as the cities and the ghost towns located along it.

Before you get started, I'd like to explain something about the writing of this book. Many paranormal research investigators believe that there is a distinct difference between a ghost and a spirit. I do not. Since there is no scientifically accepted evidence for the existence of either ghost or spirit, I believe I am safe in using the words interchangeably. But this doesn't mean that I don't believe in the existence of ghosts. Having had a number of experiences that can't be so easily rationalized and explained, I definitely do. And I will definitely continue my quest for evidence in the form of EVP (electronic voice phenomena) and photography that will stand up to the harshest of doubters. Notice that I did not use the word *skeptic*. This is because any good paranormal research investigator should also be somewhat of a skeptic. Not everything is a ghost, no matter how much we may want it to be so. In writing this book, I use "ghost hunters" and "ghost research/investigators" interchangeably. I apologize to the ghost research/investigators who won't appreciate this, but like Shakespeare's Juliet said, "A rose by any other name would smell as sweet." I have also used the names Highway 50 and Loneliest Road interchangeably. They are one and the same. Now back out on the road.

LEGENDS AND LORE

James M. Sweeney of Eureka burst a blood vessel
while laughing and bled to death.
—Daily Nevada Journal, *August 16, 1883*

ALONG THE ROAD

Osceola

There's not much left of this once thriving town on Wheeler Peak, forty-five miles east of Ely. After the 1877 discovery of placer gold, an influx of gold seekers rushed to the area, and the town of Osceola was founded. Scavengers and the ravages of time have taken their toll. Looking around today, it is hard to believe that there was once a school, a jail, a hotel and several saloons here.

Not everything is lost. The old Osceola cemetery is still here. Overrun with sagebrush and weeds, the cemetery is the final resting place of fifty people. The town blacksmith, Joe Ayers, is one of them. In July 1879, he foolishly challenged Captain Akie to a duel and lost. The men were arguing over a mining claim, and Ayers asked if Akie was armed. When Akie replied that he wasn't, Ayers said, "Go arm yourself damn quick." Akie did so and returned to accept Ayers's challenge. But Ayers wasn't so

"damn quick" enough—he lost his life there on the street in a gun battle he had egged on.

The Osceola mining district produced more gold than any other in Nevada. The largest gold nugget (weighing in at twenty-five pounds,) ever discovered in Nevada was found near Osceola on the claim of John Verzan. The nugget, valued at $5,000 in early twentieth-century money, proved to be unlucky for the man who found it, an employee of Verzan who got greedy. After stealing the nugget, he took it to an assayer in a nearby town and had it melted into bars. His future was set. He was delirious with thoughts of the wealthy man he would soon become. But as he rode down Main Street with the gold bars, he met Verzan. Suddenly, guilt got the better of him. He began weeping as he confessed his deed and handed over the gold bars to Verzan, who was none the wiser. Word got out of his theft and his confession. He soon became the laughingstock of Osceola. There was nothing for him but to leave town in disgrace.

People talked and word spread quickly. The tale of the nugget and of how he had returned it followed him wherever he went. Eventually, he returned to Osceola, a broken man. One night, he drank too much, and self-pity got the best of him. He loaded his gun and ended his life. He, too, rests in the Osceola Cemetery, in an unmarked grave.

Did I say "rests"? Well, not exactly. The man is said to wander about the old ghost town, hoping to be absolved of his gold nugget guilt. Laughter drives him away. Don't try explaining that time has passed and that all those involved are long dead. Just laugh at him. And watch how fast he beats it back to the afterlife.

Stokes Castle

Ask any ghost hunter who's ever gotten close enough to Stokes Castle, which sits behind a chain link fence (no trespassing!). They'll tell you that there's got to be a ghost in residence. Just look at the place. Is there really a castle outside Austin? Well, yes and no. It is more of a tower than a castle, but it is referred to as Stokes Castle. In 1896, Anson Phelps Stokes decided that he wanted a summer home built in Nevada. The resulting home was designed to be similar to a tower he'd once seen in Italy. Austinites were curious about the new home. In its June 14 and July 1896 issues, the *Reese River Reveille* eagerly informed its readers of the building's progress:

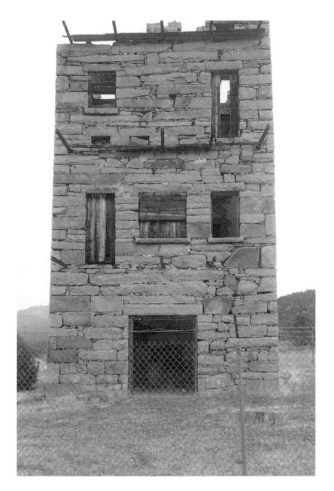

Stokes Castle. *Photo by Jeff Frey.*

A large force of men and teams began work on the new grade which starts at a point below town and just above the old brewery—as soon as the grading is finished a large tower or castle of two stories and about 30 feet high, one room to each story, will be built of stone and plate glass. This castle is being built for Mr. Stokes, a wealthy New Yorker and one of the principal owners in the Austin Mining Co., who intends to spend the summer months with his family in Austin. The plans were drawn by Mr. Stokes himself and received last week.

The Stokes Castle west of town is fast nearing completion. The masons are again employed at the mill. The lower room has received two coats of plaster and Mr. Stevens has a force of carpenters at work putting in flooring etc.

The new roof has a pitch from one side of 12 inches is to be of sand finish and is surrounded by a court 4 feet higher than the roof, the top of the walls resembling barracks. Over the court will be an awning and on the roof a fireplace. On the south side leading from the first floor will be a balcony.

The windows are of plate glass and the interior furnished with all the latest appliances and furniture which has arrived.

A force of men were put to work yesterday digging a ditch and laying water pipes from town to the castle.

When the building was completed the following year, it was three stories tall. The Stokes family spent June 1897 in their tower and returned for only two short intervals. Afterward, they never returned. However, Stokes continued to own mining interests in Nevada. To oversee those interests, he sent a young attorney by the name of Tasker Oddie to Nevada. A New York native, Oddie settled first in Austin. He would later go on to make his fortune in Tonopah and become Nevada's twelfth governor.

By the 1930s, the castle, located on a road once known as Lovers' Trail, had changed hands several times and was up for sale. According to an article in the August 28, 1934 issue of the *Nevada State Journal*, J.F. Byer of Austin was trying to sell it along with some mining claims. Byer told the reporter, "I'll give the castle and some ground to anybody who will put it back in shape like it was, and keep it that way. I'd like to do that for old Austin. The old place is in a pretty bad way now. But it really should be preserved."

The walls were littered with graffiti, and the windows and the doors were all broken. Apparently, no one took Byer up on his offer until 1956, when Molly Magee Knudtsen, a cousin of Anson Phelps Stokes, arrived in Austin and bought the castle. Speaking to a journalist, she said, "That castle has always been here. It belongs to Austin to the history of this lonely place and to the few people who live here."

During Mrs. Knudtsen's ownership, a fence was erected around the castle, and its windows were boarded up. If not for her efforts, the castle would probably not be standing outside Austin today. Still, the years passed. With no one to take care of it, Stokes Castle fell into disrepair. But no one has lived there since that brief summer in 1897. Over the years, there have been reports of mysterious lights that seem to move about in the castle. Could this be the lonely ghost of a Stokes family member or perhaps a curious trespasser? We know this cannot be a ghost hunter, as no self-respecting ghost hunter would ever trespass just to look for ghosts.

If you truly want to take a tour of Stokes Castle, and who wouldn't, you're in luck. Every September, Austin puts on its annual Prospector's Dream Wine Walk. The walk includes wine—as Austin says, "A sip of wine and a taste of the town." Walkers start at the museum and meander along several locations on Main Street. At 5:00 p.m., a hay wagon picks everyone up, and off to Stokes Castle they go for a dinner and a tour of the castle. This sounds like so much fun and a great way to see Austin and the inside of the Stokes castle. Please put me down for next year!

Singing Sand Mountain

If you're traveling along Highway 50, you're bound to notice the large white sand dune that sits incongruously a mile or so off the highway. This is Sand Mountain, and it's a singing mountain, which is a rare thing. The local Paiute Shoshone peoples know the reason the Sand Mountain sings. They say it's the hissing of an ancient sea serpent they call Kwansee. According to another legend, a man named Kwasi and his wife lived beneath the Stillwater Mountains near the sacred mountain, Fox Peak in the Stillwater Range, where the Paiute Shoshone people were created long ago.

Kwasi and his wife made their way through what is present-day northern Nevada offering good will, sharing their wisdom and making the people happy wherever they went. Then Kwasi's wife died. Overcome by his grief, Kwasi buried himself in the sand at the foot of the Stillwater Range. Tribal elders say that he is still alive there under Sand Mountain and continues to bestow his guidance and protection on them. Tribal leaders have requested that the Bureau of Land Management close Sand Mountain to motorized vehicles two months each year so that they can conduct their ceremonies.

There are several acoustical, booming or singing dunes in the world. Only a few are located in North America: California claims two, as does Hawaii. And, of course, there is Nevada's Sand Mountain, home of the very rare Sand Mountain blue butterfly, which is found nowhere else on earth. Sand Mountain is said to be one of best places in the United States to witness the phenomenon of booming, or singing, dunes. Lying on the edge of ancient Lake Lahontan, along Highway 50, about twenty-five miles east of Fallon, Sand Mountain is a popular site, managed by the U.S. Department of the Interior and the Bureau of Land Management. Every year, thousands of outdoor enthusiasts visit the 4,795-acre recreational area for camping, hiking, sandboarding and, of course, driving their

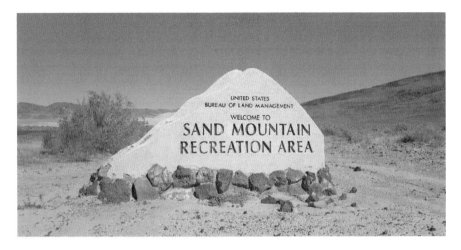

Sand Mountain Recreation Area sign. *Photo by Bill Oberding.*

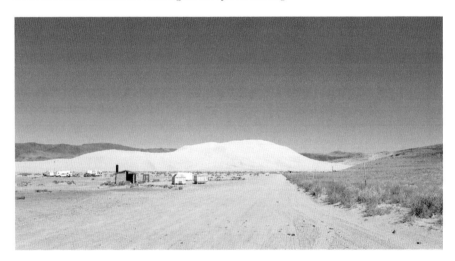

Sand Mountain. *Photo by Bill Oberding.*

dune buggies. In recent years, the riders have clashed with tribal leaders regarding the closure of the dune.

The two-mile-long by six-hundred-foot-high dune is one of the tallest in North America and attracts those who want to hear the eerie booming sounds as the wind shifts across the sands. According to scientists, the reason Sand Mountain sings is because of the warm, dry climate and the vibrations and the movements of the smooth, rounded grains of sand. Kwasi is probably content to let them continue to believe this.

Bill and I had come to take photos of Sand Mountain—and, of course, to hear the singing for ourselves. It was one of those hair-wrecking windy days Nevada is known for. As we moved this way and that, trying for a good shot, we heard the eerie humming of the mountain. It was intense. Now imagine yourself here at this very spot 150 years ago, when modern science was in its infancy. What would you make of the noise? As we listened to the sound playing across this barren landscape, we were suddenly treated to another sound: roaring jet engines. We were within a few miles of Naval Air Station Fallon—and back in the twenty-first century.

Pony Express

For all the stories, the legends and the lore, the Pony Express was only in operation for eighteen months from April 1860 to October 1861. And yet the Pony Express is deeply rooted in Nevada's history. One ad noted, "Wanted, young, skinny, wiry fellows not over eighteen. Must be expert riders, willing to risk death daily. Orphans preferred. Wages $25.00 per week." Twenty-five dollars per week was a lot of money back in 1860, enough that the Pony Express hoped to lure riders. Orphans were preferred because no one wanted anxious mothers wondering about their sons. Willing to risk death daily was a given. The young riders would be covering a lot of ground in hostile Indian territory. Once hired, the rider had an oath to take.

> *I…do hereby swear, before the Great and Living God, that during my engagement, and while an employee of Russell, Majors and Waddell, I will, under no circumstances, use profane language, that I will drink no intoxicating liquors, that I will not quarrel or fight with any other employee of the firm, and that in every respect I will conduct myself honestly, be faithful to my duties, and so direct all my acts as to win the confidence of my employers, so help me God.*

William H. Russell, William B. Waddell and Alexander Majors devised a plan to speed mail delivery to the far west. They called their new venture the Pony Express. With a 150 stations, 100 riders and 400 ponies, the Pony Express began operation on April 3, 1860. Armed with their *mochila* filled with mail, the riders would saddle up a fresh horse and race it to the next station, a distance of about ten miles. There they would mount another

Desert along the Loneliest Road. *Photo by Bill Oberding*

horse and continue on to the next station. Their journey was about one hundred miles and was often fraught with danger.

Sand Springs and Cold Springs Station are two of the Pony Express stations along the Loneliest Road. Very little remains of Sand Springs Station (near Singing Mountain) other than a few crumbling walls. An interpretive trail and the ruins of Cold Springs Station (behind a chain link fence) are about fifty-nine miles east of Fallon on current Highway 50 and can be visited by walking trail. On a quiet day, when the wind is still, if you listen carefully, you can almost hear the sound of hooves racing across the desert toward the station.

Cold Springs was but one of Nevada's numerous stations. In his 1861 book *City of Saints and Across the Rocky Mountains to California*, British adventurer Sir Richard F. Burton, who visited several of the Pony Express stations, wrote the following about the Cold Springs Station, which he visited in October 1860:

> *The station was a wretched place half built and wholly unroofed; the four boys, an exceedingly rough set, ate standing, and neither paper nor pencil was known amongst them. Our animals, however, found good water in a rivulet from the neighboring hills and the promise of a plentiful feed on the morrow. Whilst the humans, observing that a beef had been freshly killed supped upon an excellent steak. The warm wind was a pleasant contrast to*

the usual frost but as it came from the south all the weather-wise predicted that rain would result. We slept however without such accident, under the haystack, and heard the loud howling of the wolves, which are said to be larger on these hills than elsewhere.

Pony Bob Haslam may be the most famous Pony Express rider. He certainly is in Nevada, thanks to his famous record-breaking 380-mile round-trip ride from Bucklin Station to Smith's Creek. During this ride, Pony Bob stopped at the Cold Springs Station and then went on to Smith Station near Austin. In the 1908 book *A Thrilling and Truthful History of the Pony Express, or Blazing the Westward Way* by William Lightfoot Visscher, Pony Bob Haslam recounted that round-trip ride.

After remaining at Smith's Creek about nine hours, I started to retrace my journey with the return express. When I arrived at Cold Springs to my horror I found that the station had been attacked by Indians, the keeper killed and all the horses taken. I decided the best course to pursue—I would go on. I watered my horse having ridden him thirty miles on time, he was pretty tired, and started from Sand Springs, thirty seven miles away. It was growing dark, and my road lay through heavy sage brush, high enough in some places to conceal a horse, I kept a bright lookout, and closely watched every motion of my poor pony's ears, which is a signal for danger in an Indian country. I was prepared for a fight, but the stillness of the night and the howling of the wolves and coyotes made cold chills run through me at times; but I reached Sand Springs in safety and reported what had happened. Before leaving I advised the station keeper to come with me to the Sink of the Carson, for I was sure the Indians would be upon him the next day. He took my advice, and so probably saved his life, for the following morning Smith's Creek was attacked.

Among Nevada's Pony Express tales is that of the Egan Station, just south of Cherry Creek. Egan Station was one of the loneliest change stations in the region. One August morning in 1860, after arriving at the station, express rider Slim Wilson sat down for a brief conversation with Mike Holden, who tended the station. Wilson had a long, weary journey ahead of him and nodded off as Holden talked.

The serenity was shattered when a group of angry Paiute warriors burst through the door. Other stations had recently been attacked, with everyone slaughtered, so Holden and Wilson held no hope for their survival. They

resigned themselves to their fate. All they could hope was that their deaths would be quick. And then the inexplicable happened: the Paiutes looked in the breadbox and found it was empty.

"We are hungry. We want bread." They demanded. "You will make bread."

The shocked men looked at each other. Were they to live after all?

"We want bread, now!" the Paiutes demanded.

The rest of the day was spent with Mike Holden and Slim Wilson elbow deep in flour and yeast. As fast as they brought out one loaf, another went in the station's brick oven. At dusk, their appetites sated, the warriors prepared to burn the two bakers alive. What they didn't know was that another Pony Express rider had seen them rush the Egan Station. He'd quickly ridden back and alerted soldiers he'd passed on the trail earlier.

Luckily for Holden and Wilson, the soldiers, under Lieutenant Stephen H. Weed, arrived just in time. The *San Francisco Daily Evening Bulletin* of August 21, 1860, reported on the skirmish:

> [They demanded] *some powder and lead of the men in charge of the station, which they refused to let them have as a matter of course. They then wanted some provisions, and the men gave them two sacks of flour, and some sugar and coffee. One of the men then started out after the animals kept at that place, when the Indians told him that he could not go, and that they would take care of the animals themselves, and commenced singing and hallooing at a great rate. At that instant Lieutenant Weed, with twenty-five soldiers, came up and attacked the Indians, who returned the fire, wounding three men.… The Indians fled without driving off any of the stock. About the same time, six or eight Indians went to where some men were mowing, near Deep Creek, and ordered them away, but went off without molesting them further. They came back next morning, when four soldiers, who had secreted themselves in a wagon, fired on them, wounding two mortally. The others fled.*

But all was not forgotten. The Paiutes returned two months later in October 1860 and burned the station to the ground in retaliation for the deaths they had suffered at the hands of the soldiers.

Grimes Point Archaeological Area (Hidden Cave)

Native American history is an integral part of Nevada's history. These indigenous people lived in the area that would become Nevada centuries before the Pilgrims landed on Plymouth Rock and before explorers came west. Located in the southern part of our state is the Lost City, which was inhabited thousands of years ago. Here in northern Nevada, you need only travel along the Loneliest Road to discover where these ancient civilizations lived. Hidden Cave is located about two and a half miles off Highway 50 in the Grimes Point Archaeological Area ten miles southwest of Fallon. An old Fallon story—a stagecoach robber was being chased by a posse when he hastily hid his ill-gotten gold in a cave near Grimes Point— led to the cave's discovery.

Four teenage boys set out in search of the loot in 1927. What they discovered was a treasure-trove of centuries-old Native American artifacts. But as secrets go, the boys couldn't keep theirs forever. Soon, word got out about the cave and what it contained. One of the first archaeologists to investigate the cave was Mark Raymond Harrington, who had excavated the Pueblo de Grande (the Lost City) near Overton, Nevada. Later, in 1935, Sydney and Georgia Wheeler would come to study, photograph and excavate Hidden Cave. The cave received its name when, during an earlier exploration, Harrington made an offhand remark about the difficulty in finding its entrance.

Among the items the Wheelers found in the cave were animal bones, shells, wooden tools, atlatls and other such weaponry. In addition, it was noted that at least five burials had taken place in the cave. The Wheelers believed that the cave was a place of storage rather than where these early people dwelt. Subsequent archaeologists agreed with their findings.

If you would like to see the interior of this remarkable cave, be sure to visit the Churchill County Museum in Fallon. The museum and the Bureau of Land Management offer free guided tours of the Hidden Cave. Visitors can also take a self-guided hike along a petroglyph trail outside Hidden Cave.

The ghosts here at Grimes Point have been here a very long time. People have been talking about the ghostly sights they've seen here in this area for years. Invariably, they report strange flickering lights and silent hovering figures that almost seem to shimmer.

Spirit Cave Man

In 2016, after a long and bitter court battle, he was once again to be consigned to the earth. He is known as Spirit Cave Man, and he lived in this region more than ten thousand years ago. This is how he became the subject of a legal dispute thousands of years after his death.

In August 1940, archaeologists Sydney and Georgia Wheeler were studying the caves and rock shelters near Grimes Point. After unearthing textiles and other artifacts, the Wheelers found the partially mummified remains of an ancient man who was shrouded in a rabbit-skin blanket and reed mats; on his feet were moccasins. He would come to be known as Spirit Cave Man. The remains were carefully unearthed and taken to the Nevada Museum in Carson City. There they were kept under lock and key in a long wooden box until they could be studied. More than fifty years would pass before science could accurately determine Spirit Man's age. By using a new radiocarbon dating technique, Carbon-14 analysis, they found that he had lived and died more than 10,600 years ago. That made Spirit Cave Man the oldest Nevadan—indeed the oldest North American. Further examination determined that the five-foot, two-inch-tall Spirit Cave Man was about forty years old at the time of his death and that he suffered chronic back pain, gum disease and infections. And we thought those were modern-day maladies.

The Fallon Paiute-Shoshone tribe felt that Spirt Man was their ancestor, one who should be reburied so that he could continue his journey into the next world. Anthropologists and scientists didn't want to lose their opportunity to study his remains. And so the battle moved into the federal courts. Under the 1990 law Native Americans Grave Protection and Repatriation Act (NAGPRA), the tribe claimed the right to rebury Spirit Cave Man without further scientific testing.

Using genome sequencing and DNA testing, scientists determined that Spirit Cave man was closely related to Native Americans, and he was handed over to the tribe for reburial.

The cave where Spirit Man was discovered is known as Spirit Cave. It's one of the most famous caves in the northern Nevada desert, located somewhere near the Stillwater Range, east of Fallon. But only a few people know its exact location. Because sites are protected under the Archaeological Resources Protection Act of 1979, no one but certain state employees and archaeologists who hold valid state and federal antiquities permits are privy to information on the location. The Freedom of Information Act won't help you on this one, as this information is exempt from FOIA as well. Like

many such burial caves, Spirit Cave is located on public land, and people occasionally stumble on to the site by accident. This makes Nevada all the more cautious in preventing theft and plunder of archaeological sites within the state.

Si Te Cah: The Red-Headed Giants

Sarah Winnemucca was a remarkable woman. Sometimes referred to as the "Paiute Princess," she was the granddaughter of Captain Truckee and the daughter of Paiute chief Winnemucca. Unlike some other leaders, Chief Winnemucca believed in a peaceful coexistence with the early nonnative settlers of Nevada. The chief also saw that his daughter Sarah received a good education in a Catholic school in Santa Clara. This would serve her well in later life.

When her mother was killed in an attack by U.S. cavalry, Sarah Winnemucca's life was forever altered. She felt that someone had to speak out for native rights. She became that someone. Nevada is proud of Sarah Winnemucca's contributions to our state. In 2005, Nevada contributed a statue of Sarah Winnemucca to the National Statuary Hall Collection. This was a well-deserved honor for the woman who had worked so tirelessly throughout her life for her people.

In her book *Life Among the Piutes: Their Wrongs and Claims*, Sarah Winnemucca wrote of Si Te Cah:

> *Among the traditions of our people is one of a small tribe of barbarians who used to live along the Humboldt River. It was many hundred years ago. They used to waylay my people and kill and eat them. They would dig large holes in our trails at night, and if any of our people travelled at night, which they did, for they were afraid of these barbarous people, they would oftentimes fall into these holes. That tribe would even eat their own dead— yes, they would even come and dig up our dead after they were buried, and would carry them off and eat them.*

They were redheaded and stood about ten feet tall. According to Paiute oral history, they were a race of giants who roamed ancient Nevada, cannibalizing their enemies and wreaking havoc everywhere they went. One legend holds that the giants kidnapped women of other tribes and took them as their brides. Their skeletons were discovered in 1912 under a thick layer

of guano in Lovelock Cave. Other items found in the cave were duck decoys, whistles and blankets made of mouse skins. Lovelock Cave was placed in the National Register of Historic Places in 1984.

In *Life Among the Piutes*, Sarah Winnemucca wrote how the end of Si Te Cah came:

> *At last one night they all landed on the east side of the lake, and went into a cave near the mountains. It was a most horrible place, for my people watched at the mouth of the cave, and would kill them as they came out to get water. My people would ask them if they would be like us, and not eat people like coyotes or beasts. They talked the same language, but they would not give up. At last my people were tired, and they went to work and gathered wood, and began to fill up the mouth of the cave. Then the poor fools began to pull the wood inside till the cave was full. At last my people set it on fire; at the same time they cried out to them, "Will you give up and be like men, and not eat people like beasts? Say quick—we will put out the fire." No answer came from them. My people said they thought the cave must be very deep or far into the mountain. They had never seen the cave nor known it was there until then. They called out to them as loud as they could, "Will you give up? Say so, or you will all die." But no answer came. Then they all left the place. In ten days some went back to see if the fire had gone out. They went back to my third or fifth great-grandfather and told him they must all be dead, there was such a horrible smell. This tribe was called people-eaters, and after my people had killed them all, the people round us called us Say-do-carah. It means conqueror; it also means "enemy." I do not know how we came by the name of Piutes. It is not an Indian word. I think it is misinterpreted. Sometimes we are called Pine-nut eaters, for we are the only tribe that lives in the country where Pine-nuts grow. My people say that the tribe we exterminated had reddish hair. I have some of their hair, which has been handed down from father to son. I have a dress which has been in our family a great many years, trimmed with this reddish hair. I am going to wear it some time when I lecture. It is called the mourning dress, and no one has such a dress but my family.*

There are those who will put the entire story of the redheaded giants down to nothing more than a tall tale. But others aren't so quick to dismiss the Si Te Cah. There is the claim that a fifteen-inch-long sandal-type shoe was among the artifacts found at Lovelock Cave.

Several years ago, a fellow Nevada historian told me that during a youthful desert exploration, he had discovered what he was certain were the bones of the redheaded giants off the Pyramid Lake Highway. He felt that the only respectful thing to do was to carefully reinter them and go on his way. And he did so, knowing that the Si Te Cah had indeed existed.

Nevada's Last Lynching

Hazen's glory days are long gone. Today, it's just a blip on Highway 50 alternate—blink and you'll miss it. It was a lot different in 1905, when it was a Southern Pacific Railroad stop, complete with a depot, saloons and hotels. People lived and worked here. On the last day of February 1905, the town's worst resident, William "Red" Wood, was cooling his heels in the local jail. An impatient mob wasn't content to let justice take it course. It overran the jail, and Wood was taken from the jail under cover of darkness by vigilantes.

Hazen was a safe town, and people meant to keep it that way. The mob led him to a nearby telegraph pole, where he was quickly hanged. His crime? Although he was suspected in the murder of his business partner, Wood was only jailed for robbery. But that was enough for the town's vigilantes. They were tired of the criminal element that had come to Hazen in recent months. Wood's reputation was such that the *Reno Evening Gazette* described him as "a notorious thug and all around bad man" when reporting the lynching the next day.

Later, a photograph of the dead man hanging from a telegraph pole would appear in newspapers throughout the country. But Wood was dispatched in darkness—no one but the mob that strung him up was present. Still, a photo op is a photo op. Wood was buried and forgotten, until an out-of-state newspaper man came to town for a story and a photograph. No time was wasted in digging up Wood's corpse and reposing it on the telegraph pole. He wouldn't know the difference, they reasoned.

The people of Hazen couldn't have cared less about the lynching of William "Red" Wood. He was just another bad guy who had answered for his crimes at the end of a rope. Then, as now, journalists knew a good story when they saw one. For the next few weeks after the lynching, local newspapers continued to regale their readers with details of the lynching. From the *Reno Evening Gazette* of March 1, 1905:

CONSTABLE'S STORY

"I never dreamed of anything like that," said Constable Allen. "I had a man guarding the Jail until about midnight, but I thought everything was quiet. I told him to go to bed. There are two keys to the locks. Both were in my possession. I did not hear a sound during the night, and could hardly believe it when I got up in the morning and found that 'Red' had been lynched. No, I suspect no one. I have conducted no Investigation. There was an inquest held this morning."

From the *Daily Nevada State Journal* of March 8, 1905:

ALTHOUGH IT is several days since the lynching at Hazen the echoes of that affair have not yet died away. The various newspapers throughout the country are still commenting on It and pointing out to their readers the lawless condition of Nevada, and making unflattering comments on the quality of Justice in our Frontier State. It is the law that is responsible for such crimes as that of the lynching at Hazen and the undesirable notoriety that Nevada has received and will receive through that act. When safeguards are thrown about criminals who that years must elapse between the conviction and the penalty, even when the crime is a dastardly and unjustifiable murder, it's no wonder that offenses against the law are bold and numerous and that some 'such repressive measure as the lynching at Hazen is carried into effect.

If you should happen to be out and about in that area some night and come upon a man who doesn't seem quite coherent, you just may have stumbled on the ghost of the unfortunate William "Red" Wood. The talk is that he's never left the area. In his Colonnade Hotel Facebook blog, Mike Popovich, co-owner of an antique store located near the site of Wood's hanging, tells of a tourist who stopped in the store one afternoon and spent several minutes poking around the store. Finally, she looked at Popovich and informed him that a ghost by the name of Red was in residence. Considering the postmortem indignities he suffered just for a photograph, it's easy to understand why Red might be hanging around (no pun intended).

Unsolved Hazen

Regarding the unexplained weeping that is occasionally heard in and around the lonely area of Hazen, at about the time William "Red" Wood was lynched, a young woman was murdered in a cave near Hazen. The February 13, 1906 issue of the *Reno Gazette Journal* carried the story of the partially burned woman's skeleton that was discovered in February 1906 by Dr. A.V. Saph and a friend. After examining the bones, Dr. Saph concluded that the woman had been dead for about a year and had been killed by a sharp instrument that pierced her skull. In the time long before the discovery of DNA, the only identifying characteristic of the head was its extremely long brown hair.

The murder was never solved; ironically, while Wood was lynched for nothing more than robbery, the killer of this young woman got away clean. He would never face justice for his callous act.

Middlegate Station, the Shoe Tree and the Ghosts

Local lore has it that author Stephen King traveled Highway 50 in 1991 while working on his novel *Desperation*. For a brief time, he stayed at Middlegate. Middlegate was established as a stage stop and later was used as a Pony Express station. Today, there is a motel and a restaurant.

There's also a shoe tree at Middlegate. Shoe trees are part of America's roadside culture. The tall cottonwood tree that stood on Highway 50 laden with shoes of every size and description is long gone. The original shoe tree was chopped down by vandals one night several years ago.

Middlegate sign.
Photo by Bill Oberding.

The search is still on for those who were responsible. The old shoe tree is dead—long live the new shoe tree. The new shoe tree has already been christened with shoes. It is the place to toss an unwanted pair of shoes for good luck, for posterity or just because. Hopefully vandals will leave this tree alone. If not, well, there is that story about bad luck for anyone who dares to topple a pair of shoes from the tree or the tree itself.

And while I'm on the subject of luck, if you happen upon Middlegate Station and you're hungry, you're in luck. The restaurant is said to serve up some tasty food, including one of the best jalapeño burgers in the world. Those who've stayed the night in the motel claim that it's haunted. As proof, they say there are the sounds of phantom footsteps, slamming doors and howling laughter.

Lehman Caves

Ab Lehman of Snake Valley, reports that he and others have struck a cave of wondrous beauty on his ranch near Jeff Davis Peak. Stalactites of extraordinary size hang from its roof and stalagmites equally large rear their heads from the floor....The cave was explored for about 200 feet when the points of the stalactites and stalagmites came so close together as to offer a bar to further progress. They will again explore the cave armed with sledgehammers and break their way into what appears to be another chamber.

—White Pine Reflex, *April 15, 1885*

Located about sixty-seven miles east of Ely are Nevada's natural wonders known as the Lehman Caves in the Great Basin National Park. If you plan on visiting the wondrous caves, know that you will only be able to do so as part of a guided tour. It is recommended that visitors reserve tickets in advance. The tours sell out fast and are available every day except Christmas, Thanksgiving and New Year's Day. Two tours are offered: the Lodge Room Tour and the Grand Palace Tour. Each tour is limited to twenty people.

Like so many of Nevada's other discoveries—like Tonopah's silver and the gold at Pony Canyon near Austin—the Lehman Caves were discovered because of a horse. According to one of the many stories of how the caves were discovered, it was Absalom Lehman's horse that was responsible. In 1885, Lehman was out for a ride on his ranch. When his horse stumbled,

Lehman dismounted to see what had caused the animal to miss its footing. The earth felt soft beneath his feet. He looked down and discovered the wondrous caves below. Although there are numerous stories as to how the caves were discovered, one thing is certain: when you are on this side of the Loneliest Road in America, you do not want to miss the opportunity to tour the Lehman Caves.

Ward Charcoal Ovens State Historical Park

This is one of the most unusual sites you will discover along the Loneliest Road. The six beehive-shaped charcoal ovens are manmade wonders. The ovens are not small; they are thirty feet high and twenty-seven feet in diameter. Located about twenty miles from Ely, you'll find the ovens at the Ward Charcoal Ovens State Park, and they were built and used from 1876 to 1879. The ovens were built by Italian immigrants (*carbonari*) near the town of Ward for creating charcoal, which was necessary for processing silver ore. But the silver here in Ward was never what it was in other parts of Nevada. The town dwindled from a population of nearly two thousand to two hundred or so as the silver was depleted.

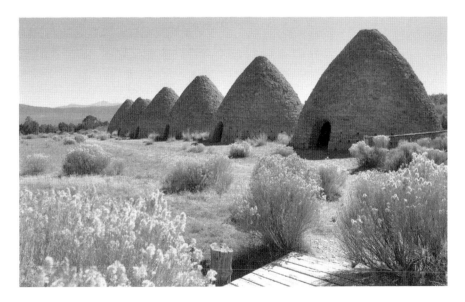

Charcoal ovens. *Chris Moran/Travel Nevada.*

There was no longer any legitimate need for the ovens, but they didn't stand idle. It's said that the well-made ovens served as shelters for travelers and even hideouts for robbers. In 1971, the Ward Charcoal Ovens were listed in the National Register of Historic Places. Privately owned until 1956, the Ward Charcoal Ovens State Historical Park was designated as a state park in 1994. Pack a picnic lunch and spend the day—and maybe a night. There's no need to rush off. The park offers facilities for camping and picnicking. Bring your camera, as you will want to take lots of photographs.

Berlin-Ichthyosaur State Park

I bet you didn't know there are some prehistoric sea monsters off the Loneliest Road in America. Berlin-Ichthyosaur State Park is a 143-mile side trip off Highway 50. It's well worth it, especially if you want to see a complete skeleton of the extinct reptile the ichthyosaur, which also happens to be Nevada's state fossil. Millions of years ago, ichthyosaurs swam the earth's waters. The largest of these mysterious marine reptiles lived in the ancient Lahontan Sea, which covered most of what is present-day Nevada. The fossils discovered at the ghost town Berlin are of these prehistoric creatures, which attained a length of more than fifty feet.

With more than two hundred people living and working at the camp, Berlin was a thriving gold mining camp from the mid-1800s until the turn of the century. As they worked, miners sometimes came across strange-looking bones. Some of their cabins were decorated with the larger fossils. As necessity is the mother of invention, an early tale has some resourceful miners using the smaller fossils as cooking and eating utensils.

Like so many of Nevada's early mining camps, Berlin didn't last long. The mines that had produced nearly $1 million were nearly played out by 1900. The camp sank into decline as its residents moved on.

In 1928, the fossilized remains of the ichthyosaurs were discovered by a member of the scientific community. Twenty-six years later, a group of paleontologists with the University of California–Berkeley came to Berlin to begin excavating the area. In 1957, the Berlin-Ichthyosaur State Park was established in order to protect and display what would ultimately become North America's largest concentration of ichthyosaur fossils. Excavation of the site continued until well into the 1960s.

At least forty ichthyosaurs were unearthed at Berlin during this time. These were named *Shonisaurus populanis* because the site of their discovery

is near the Shoshone Mountain Range. The 1,153-acre Berlin-Ichthyosaur State Park is out in the middle of nowhere, well off the beaten path. It's a registered natural landmark, and the ghost town of Berlin is on the National Register of Historic Places.

ELY

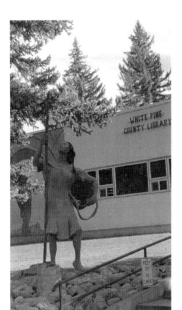

Sculpture of a Shoshone woman gathering pine nuts. Created by artist Joe Pachak with Native American helpers. The sculpture is located in front of the Ely Library. *Photo by Bill Oberding.*

Every city along Highway 50 is uniquely Nevada, with its own history, special places to see and things to do. Ely is Nevada's city of murals. It is also the county seat of White Pine County. With a little over four thousand residents, it is still the largest city in White Pine County. Ely might be small when compared to Nevada's larger cities, like Reno and Las Vegas, but don't let that deceive you. The historic little railroad and copper mining town proudly embraces both its history and its art.

The Ely Renaissance Society, founded in 1999, commissioned the more than twenty murals that adorn buildings throughout the downtown area. The murals celebrate the history and the diverse people of Ely and the region. Murals that depict the Lehman Caves and Italian railroad workers and the sculpture of Shoshone women gathering pine nuts (at the White Pine County Library) are but three colorful subjects that visitors can enjoy. You can see them all. Just grab a free map for the Ely Historic Mural Walking Tour and be on your way.

Ely is also proud of the Nevada Northern Railway Museum and its two popular train rides, the ghost train and the Polar Express. There is also the fact that a little girl from Ely made it all the way to the White House: former first lady Patricia Nixon, wife of the disgraced thirty-seventh U.S. president Richard Nixon. Mrs. Nixon may have been raised in California, but she was

Top: Lehman Caves mural, presented to Ely by the National Speleological Society; *Middle*: *Communications Then and Now*, mural by Don and Jared Gray; *Bottom*: Hotel Nevada mural by Larry Bute, who did all the hotel's murals except for the burro that has been on the east side of the building since the 1930s. *Photos by Bill Oberding.*

born in Ely, Nevada, and she is the only Nevadan to have made it to the White House thus far.

Where other mining towns produced gold and silver, Ely produced copper. And copper was king here. Ely had a good thing going until the price of copper fell. Ely still has a good thing going in regards to its places to see and explore.

Ely UFO Crash

Over the years, there have been numerous reports of UFOs along the Loneliest Road in America, especially in the Eureka and Ely areas. Interest in the skies is nothing new. Flying saucers were all the rage in the mid-twentieth century. What was out there? Movies about creatures visiting from other galaxies hit the theaters, and stories about sightings were regular newspaper items. On June 28, 1950, the *Reno Evening Gazette* carried a story about Ely. It seemed that hundreds of the town's residents had reported seeing something strange in the night sky. The object was described as spiraling smoke that could have been a falling airplane—or a flying saucer. Reports of flying saucers or UFOs were common throughout Nevada.

Two years later, on August 8, 1952, another story appeared in the *Reno Evening Gazette* concerning flying saucers. But some newspapers were tired of such stories. The Ottawa, Illinois *Republican-Times* didn't like all the saucer sightings being reported and decided that it would no longer "feed such pap" to its readers. In refusing to carry stories about strange objects in the sky, the newspaper invited the thousands of other newspapers across the nation to join it in denying space to saucer stories. They didn't. Stories of mysterious glowing objects that raced across the Nevada skies continued to appear in print. Still, not all saucer stories made the news.

According to an Ely tale, a young woman was entertaining dinner guests one August evening in 1952 when she happened to look out at the horizon. She couldn't believe her eyes as a flying saucer crashed to earth. Those who were first on the scene soon realized that the strange craft was not of this earth and that all of its occupants were dead. Apparently, the space travelers had been killed on impact.

Before anything else could be learned, the government (as it is wont to do) sent a highly secretive team to confiscate what was left of the strange vehicle and all sixteen bodies of the space aliens onboard. A similar story had made Roswell, New Mexico, a household name. But not so in Ely. The UFO crash incident was soon forgotten by outsiders. Still, some Ely residents continued to watch the sky.

Garnet Hill

I'm a Nevadan. Naturally, then, I believe that anything another state might have, Nevada has as well. Take Arkansas, with its Crater of Diamonds State Park. Yes, it is impressive. I spent some time there in the mud searching for my very own sparkler. It didn't happen, but it was fun nonetheless. The state of Nevada might not offer diamonds, but it is multifaceted and rich in other minerals and ores: turquoise, opals, gold, silver, copper and, recently, lithium, which will power batteries for electric cars. Those traveling the Loneliest Road in America may think that they've seen it all. But they haven't if they haven't visited Garnet Hill, a favorite with rock hounds, located four miles northwest of Ely. Garnet Hill has been known to produce gem-quality garnets. The garnets found here are dark, almost black. They may not be as nice as Arkansas's diamonds, but they're probably more plentiful.

Though there are garnets, be aware that there might also be rattlesnakes. The slithery creatures have been spotted in this area before.

Operation Haylift

The old B-movie *Operation Haylift* is occasionally shown on late-night TV. It's based on a true event that centers on the Ely area.

The winter of 1948–49 was the worst to strike the western United States since 1889. With thousands of cattle and millions of sheep trapped and starving in deep snowdrifts, the Ely area was hit especially hard. The United States Air Force came to the rescue with its C-82s, sometimes known as "Flying Boxcars" for their cargo-hauling capability. The flying boxcars would drop more than five hundred tons of alfalfa for the starving animals in northern Nevada and Utah. Ely was the center for the operation, which would become known as Operation Haylift.

Hollywood, as it always does, took notice. Here was a human interest story if ever there was one. A script was written and actors hired, and it was off to Ely for the film crew and the actors. The movie was naturally called Operation Haylift and starred Bill Williams and Ann Rutherford. The Hotel Nevada was headquarters for the film's cast and crew. This is when Ann Rutherford, who has a theme room, stayed at the hotel.

There was an article in the *Nevada State Journal* of January 12, 1950, reporting on the filming: "New movie 'Operation Haylift' began shooting in Ely today. The initial 11 members of the movie company arrived here

Monday night, seven more arrived Tuesday and 27 more actors and crew members were due Wednesday." The article continued, "Main locales will be the Hotel Nevada, Ely's main street [Aultman] office of the United Stockmen, various ranch scenes, and several locations about Ely."

That spring, Ely was living the dream, experiencing what every small town dreams of: fame and tourism dollars. It was an exciting time for Ely and the Hotel Nevada.

An April 11, 1950 story in the *Nevada State Journal* shows just how excited the town was: "All Ely is busy preparing for the big 'Operation Haylift' premiere to be held here Monday and preparing also for the arrival of movie stars Bill Williams, Jane Nigh and Joe Sawyer."

A free barbecue in the streets of Ely and the attendance of Governor Pittman were also scheduled. As proof that this was a very big deal, the photographer from *LIFE* magazine was coming to cover the world premiere.

EUREKA

Eureka is known as the friendliest town on the Loneliest Road in America. And Eurekans are certainly friendly. At the museum, gas stations, restaurants or hotels, wherever you stop, you are sure to encounter a friendly smile. I was speaking at the Eureka ParaCon recently when I happened to have a wardrobe malfunction. Luckily, I was in our room at the Sundown Lodge. Bill went to the desk to get a safety pin, which works on clothing the way duct tape performs fixit miracles on everything else. He returned empty-

The Jackson House and the Eureka Opera House. *Photo by Bill Oberding*

handed. I would have to wear something else. The clock was ticking; I started foraging wildly through my suitcase. Someone then knocked at the door. I opened it to find the woman from the front desk. In her hand was a small travel sewing kit.

"I went over and got this at the variety store," she explained.

"Thank you! How much do I owe you?" I asked.

"Nothing, just leave it here in the room for the next guest," she replied.

This is just one reason why Eureka is one of my favorite little towns in Nevada. Of course, Eureka's haunted locations and history also add to its allure.

Massacre at Fish Creek

Charcoal was necessary in the smelting process that reduces precious ore from metal. The work was grueling. Italian immigrants who worked in and around the Eureka area producing charcoal were known as coal burners (*carbonari*). They belonged to the Italian Charcoal Burners Association. In order to produce charcoal, the *carbonari* needed timber. Over time, the timber was depleted, and they were forced to move farther from Eureka. They felt that this warranted an increase in the price per bushel that they charged the smelters and mine owners. They wanted what they considered to be a fair price for their charcoal, raising the price by a few cents per bushel. This proposed price increase infuriated the smelters. They held firm and refused to negotiate. They would pay what they'd always paid for a bushel.

On August 11, the *carbonari* and other members of the Charcoal Burners union, which numbered in the thousands, marched into Eureka. If they weren't going to be treated fairly, they would riot, halting all deliveries to and from the smelters. Governor Kinkead was urged to stop the rioters by sending in the militia.

On August 19, 1879, when the sun was almost down and it was nearly dark, a sheriff's posse of eight road out to Fish Creek. Witnesses would later say that members of the posse were drunk, looking for a fight and didn't care who got hurt in the process. While the posse claimed that the *carbonari* opened fire first, the odds are against that—eight against one hundred *carbonari* and not one of the posse was injured. However, when the shooting stopped, there were five dead *carbonari* and six injured. While a coroner's jury would find that the men had come to their death by the sheriff's posse in the discharge of its duty, the town would never forget the injustice.

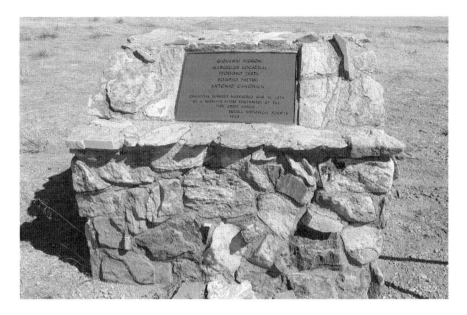

Memorial to the five men killed by a posse at Fish Creek (the Charcoal War). *Photo by Bill Oberding.*

Today, there is a memorial in the Eureka County Cemetery dedicated to the five men who were shot dead by a ruthless sheriff's posse during what would become known as the Charcoal War.

The Sentinel *Newspaper*

The *Sentinel* newspaper, like Austin's *Reese River Reveille*, was a colorful local newspaper that kept its readers entertained and informed. Today, Eureka's Sentinel Museum is housed in the 1879 Sentinel Newspaper building. The newspaper was produced in the building from 1879 to 1960. Some of the original press equipment is still on display. While in town for Adam Bogart's Eureka ParaCon, Bill and I made it a point to visit the old museum. No ghost investigations have taken place here. Because I believe that many of the items we use on a daily basis can somehow be imprinted or haunted by former users and owners, I asked myself if the old building was haunted. With little more than a gut feeling, I concluded that it surely would be. If some of the people who worked here using some of this equipment aren't hanging around the premises, then perhaps the ghosts of Dixie and Frank are.

Dixie and Frank were two unfortunate dogs that perished in the April 20, 1879 fire that destroyed much of the business district. As reported by the April 21, 1879 issue of the *Sentinel*, "The charred remains of Dixie and Frank, the two inseparable dogs connected with the Sentinel office, were found among the ruins."

We stepped out of the museum, and I heard the sound of dogs barking. Refusing to let my writer's imagination run away with me, I stopped and listened. Yes, it was definitely barking—but it was coming from a few very much alive dogs somewhere in the neighborhood.

Edna Covert Plummer: Nevada's First Female District Attorney

This is Nevada. Although women were not permitted to practice law in Nevada until 1893 and weren't allowed to vote until 1914, the gender inequities that held women down in other parts of the country didn't always apply here in the Silver State. That is especially true of the towns in this part of Nevada. On May 13, 1918, the County of Eureka appointed Edna Covert Plummer as its district attorney. This made Plummer the first female DA in Eureka County, in the state of Nevada and in the United States. Eureka was proud of having appointed a woman. In a special to the *Gazette*, an article in the *Reno Gazette Journal* of May 13, 1918, declared:

> This county is the first Nevada county to have a woman district attorney. Other counties have had women county commissioners, county clerks and other officials, but Eureka is the first county to place the important office of district attorney in the hands of a woman and to Mrs. Edna Covert Plummer wife of R.F. Plummer formerly of Mineral Hill goes the honor.
>
> Mrs. Plummer was appointed to fill the vacancy caused by the resignation of N.P. Morgan who was forced to leave Eureka on account of his health. Mr. Morgan was appointed district attorney in 1913 while he was principal of the school of Eureka and was elected to succeed himself in 1914 and 1916. With his family he left for Tennessee.
>
> Mrs. Plummer was unanimously appointed by the county commissioners to fill the vacancy and has already assumed the duties of the office. She has been a resident of Nevada for a little over five years and was admitted to practice law in this state in September 1912.
>
> She received her early education in law and did her first work in Chicago and has also been admitted to practice before the United States Supreme

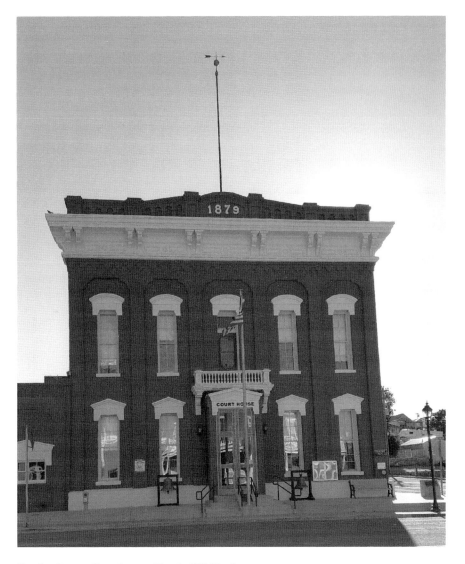

Eureka County Courthouse. *Photo by Bill Oberding.*

Court. She is a member of the Illinois bar association and also of the Chicago Women's Press Association of San Francisco. Mrs. Plummer has confined her practice largely to corporate law and probate court work.

She is director of the Eureka County Council of Defense and was instrumental in making the liberty loan drive and other war work successful in Eureka county.

In addition to this honor, she organized the Farmers and Merchants National Bank in Eureka. Unfortunately, she was defeated in the next election—a loss for our state. Edna Covert Plummer relocated to California, where she continued to practice law and served as cofounder of a legal aid foundation.

Palisade

Not everyone goes digging in mines in search of gold. Not everyone is afraid of cemeteries or the ghosts that might be resting within their gates. An Idaho man was just such a person. He went digging for gold in the old Palisade Cemetery outside the old ghost town of Palisade. It was well into the twentieth century, and he came prepared with a metal detector to seek out and find treasures. When he located something he thought might be of value, he dug. Never mind that the bones of long-dead people were buried here. Never mind that the jewelry he found belonged to these same dead people.

But someone did mind. Photographs were taken of the grave robber in action. When caught, he pled guilty and served two and a half weeks in the Eureka jail. We can only hope that this put an end to his grave robbing ways.

In 1903, three days before Halloween, a terrible train wreck left three people dead and several more injured at Palisade. A work train had backed into a passenger train at full speed.

Palisade was an interesting place in its heyday. Located about an hour and a half from Eureka, the old ghost town was owned by the family of John Sexton, an Atlanta businessman from the 1920s. In 2005, a Sexton family member sold it to an unidentified bidder for $150,000. Long before it became private property, Palisade had a reputation as one of the deadliest towns in the West. It seemed that someone was always shooting it out with someone else over the smallest infraction. This might have filled up the cemetery fast except for one small fact: the shootings were all fake. They were put on by some of the townspeople for the benefit of unsuspecting railroad passengers.

On the Road to Ruby Hill

Ruby Hill was a small mining camp just outside Eureka that was founded in the early 1870s. By 1878, there were 2,500 people living at Ruby Hill.

Today, the old ghost town is private property. If you wish to visit, you will need permission. To those who have visited and claim that there is a ghostly eeriness about the area, I offer an explanation. Perhaps the ghost of an unknown murder victim seeks justice for the cruel way in which his life was taken.

In early April 1874, a gruesome murder was committed somewhere along the road from Eureka to Ruby Hill. The April 5, 1874 issue of the *Nevada State Journal* carried the following story from the *Eureka Sentinel*: "The body of an unknown man, horribly mutilated, was found lying in the snow on the road to Ruby Hill with the arms and legs mangled to such extent that one of the latter dropped off while the remains were being conveyed to town.… The murder as it must surely be, is involved in mystery and was done with no motive of robbery as a fine gold watch and about $120 were found in the pockets of the deceased."

Could it be that this unnamed victim is seeking justice against his murderer? Certainly there are many other reasons for a haunting to take place. The story of just how Ruby Hill came to be mined could be a strong one as well. According to legend, in 1865 an Indian showed a particular rock to Owen Farrell, M.G. Cough and Alonzo Monroe. The three men were impressed. If there were more rocks like this, it could be quite a find. They gave the man ten dollars and had him take them to the area where he'd found the rock.

There they discovered that, indeed, there were more rocks like that he had shown them. The Buckeye Mine and the Champion Mine were founded, and a town was established. A mining boom followed, but it was short-lived. By the 1880s, the area was on the decline. It's possible that the man who originally showed Farrell, Cough and Monroe his rock felt cheated with the surge of people that followed. Perhaps he stays on, trying to protect what he couldn't protect in life.

Prohibition

Why would someone operate a still and make alcohol when it was against the law to do so? We could argue that they were rebels who fought against the status quo, that they saw the foolishness and futility of Prohibition. We could, but the most likely reason for operating a still was to make money. Palisade rancher Robert F. Raine and his hired hand John Brite were apparently maintaining a still at the ranch. The men got caught up in a

deadly shootout on December 22, 1922, when Raine's ranch was stormed by Prohibition officers. An earlier phone call had alerted Raine that agents knew about the still. The snow was deep and falling as the two men quickly saddled their horses and rode out to the hidden still.

Suddenly, the quiet was shattered by a man's raised voice: "Put your hands up! You're under arrest!" Raine and Brite turned their rifles toward the sound and fired. In the ensuing gunfight, federal agent Nick (Asa) Carter was shot twice in the leg. Carter, who had worked as a deputy sheriff for Sheriff Charles Ferrell of Reno, might have survived if he had received medical attention right away. But he didn't. He lay in the snow several hours waiting for his fellow officer to summon help and then for that help to arrive. By that time, his wound had gotten badly infected. He was taken to a Reno hospital, where he died on Christmas Eve in the same hospital where his wife had died five years earlier. Nick Carter's death marked the first death of a Prohibition officer in the line of duty. Law enforcement was angry.

Raine and Brite were apprehended and were charged with murder. That is when they turned on each other. Brite blamed Raine for the shooting, and Raine blamed Brite. After years and a protracted legal battle, both men were acquitted of the murder.

FERNLEY

Unlike other Loneliest Road towns that were founded because of rich ore and mining, Fernley was established as a farming and ranching community. There wasn't any more water here than anywhere else in the desert region of Nevada. But like Fallon and much of the western United States, Fernley grew and thrived because of the Newlands Reclamation Act 1902, which provided irrigation to otherwise arid locations. Fernley is a town that is big on art. Big Art for Small Towns is a joint effort launched in 2012 between the Black Rock Arts Foundation, the City of Fernley and the Burning Man Project.

Located at 610 East Main Street in Fernley's new Main Street Park, the resulting artwork is something all can be proud of. The twenty-five-foot-long tortoise sculpture was created by Fernley artist Pan Pantoja. The tortoise's back is covered with four- by four-inch ceramic tiles that were painted by Fernley students and residents with Pantoja and Reno artists Aric Shapiro and Kelsey Sweet. The tiles depict life in Fernley and Nevada. Nearby is the

 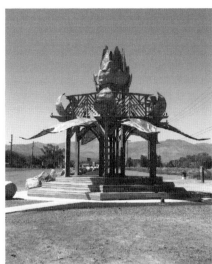

Left: Tortoise; *Right*: Gazebo. *Photos by Bill Oberding.*

colorful bottle cap gazebo by artists Max Poynton and Andrew Grinberg. The gazebo incorporates thousands of bottle caps that have been flattened and strung together with wire to form the gazebo's leaves.

Downtown Motel of Death

When reporting on the news, media doesn't always share the name of motels where a murder has taken place. This is for obvious reasons, as it's bad for business. Not everyone wants to stay in a place where a recent killing has occurred. But then again, not everyone is a ghost investigator. After a few decades have passed, ghost hunters are eager to gear up and set out on an investigation.

There are dozens of motels in Fernley. One of them is the site of an unimaginably cruel murder. Did this tragedy leave a haunting in its wake? Only motel guests who've noticed that the place feels "a bit off" or is "unhappy" could answer that. And without knowing what happened in their room, this is just how guests might describe the room's overall feel.

When traveling, my husband, Bill, has occasionally requested we be given another room because he did not like a particular room for one reason or another. When I push him for a reason, it is invariably because the room "doesn't feel right."

The murder I am referring to took place in a Fernley motel in 2000. Kathaleena Draper, a young expectant mother, and her maternal aunt, Erin Kuhn-Brown, were en route to Las Vegas. After promising to let her aunt adopt her baby, the seventeen-year-old unwed mother changed her mind. Her baby was due in a month, and Kathaleena had become excited at the prospect of being a mother. She never got the chance. Kuhn-Brown was enraged that Kathaleena had reneged on her promise. She waited until Kathaleena fell asleep and then smothered her with a pillow. As Kuhn-Brown was a medical tech, she took the baby from her dead niece's womb, but the baby died within the hour. She left the baby's body on a lonely road outside Fernley and Kathaleena's body near Sacramento.

Charged with two counts of murder, Erin Kuhn-Brown pled guilty and received a life sentence without the possibility of parole. Thankfully, this horrendous type of crime is rare. Still, people die at motels and hotels every day. Most of these deaths are natural occurrences, but not always. Trust your instincts. If you check into a room that makes you feel uncomfortable, ask for another room.

Author's note: After a bit of online research, I have discovered the name of the motel and the room number in which Kathaleena Draper died. Anyone who is curious about this can find the information within ten minutes of researching.

AUSTIN

Clara Dunham Crowell: Nevada's First Female Sheriff

Nevada has never been a state to try and hold its women back. Aside from the fact that female Nevadans would never have stood for it, Nevada believed in equal opportunities long before the law demanded it.

Clara Dunham Crowell was born on April 7, 1876, in Austin, where she was raised. As a young woman, she went to work in a local café, where she met and fell in love with George Crowell. They were married in 1898. Eighteen years later, in 1916, Nevada women voted in the state election for the first time. Two years later, George entered local politics and ran for sheriff of Lander County. He won easily. But George Crowell was in ill health. That didn't seem to matter to the voters. He was well liked in his community.

But he was very sick nonetheless, and his health continued to decline. Hoping for his recovery, Clara took her husband to California, where he died on February 24, 1919, leaving her with a child to support and no means of doing so. The Town of Austin came up with a simple solution: at forty-two years of age, Clara was appointed to fill her late husband's post. She would be sheriff of Lander County.

According to legend, Sheriff Clara Crowell handled bad hombres as well as any of her male counterparts. She was not afraid to march into a saloon and arrest a drunken lawbreaker whenever the need arose. Historians say that the facts have probably been distorted. It was her deputy Thomas White who did much of the difficult work, while Clara handled the minor details such as paperwork. Either way, Nevada is especially proud of Clara Dunham Crowell, the state's first female sheriff.

Reuel Gridley and the Sack of Flour

When you're traveling on the Loneliest Road, you don't want to hurry. Sure, there is a speed limit out on the highway, but take your time to stop and look around in the towns. Every one of them has a story to tell and sights to see. The Gridley Store Museum in Austin is one of them. The building was erected in 1863 and was renovated in 1985. It was listed in the National Register of Historic Places in 2003. Originally used as the Gridley and Hobart store, it's here at 247 Water Street that we'll begin the tale of Reuel Gridley and the sack of flour.

Reuel Colt Gridley was a well-respected shopkeeper in Austin. Born in Hannibal, Missouri, in 1829, Gridley was raised there about the same time as Samuel Clemens (Mark Twain). Gridley came west as a teenager to try his hand in the California Gold Rush. Failing to strike it rich, he moved to Austin, Nevada, where he built his store and went into business. It was because of a lost election that Gridley became famous.

In chapter 45 of his book *Roughing It*, Mark Twain claimed Gridley as a schoolmate as he explained how Gridley had raised $275,000 for the Sanitary Commission, a precursor to the Red Cross and a private relief organization founded in 1861 to care for sick and wounded military personnel (in today's dollars, that would be $4,852,878.50, and that's a lot of money):

> *After that, the Commission got itself into systematic working order, and for weeks the contributions flowed into its treasury in a generous stream.*

Gridley Store. *Photo by Bill Oberding*

Individuals and all sorts of organizations levied upon themselves a regular weekly tax for the sanitary fund, graduated according to their means, and there was not another grand universal outburst till the famous "Sanitary Flour Sack" came our way. Its history is peculiar and interesting. A former schoolmate of mine, by the name of Reuel Gridley, was living at the little city of Austin, in the Reese river country, at this time, and was the Democratic candidate for mayor. He and the Republican candidate made an agreement that the defeated man should be publicly presented with a fifty-pound sack of flour by the successful one, and should carry it home on his shoulder. Gridley was defeated. The new mayor gave him the sack of flour, and he shouldered it and carried it a mile or two, from Lower Austin to his home in Upper Austin, attended by a band of music and the whole population. Arrived there, he said he did not need the flour, and asked what the people thought he had better do with it. A voice said: "Sell it to the highest bidder, for the benefit of the sanitary fund."

The suggestion was greeted with a round of applause, and Gridley mounted a dry-goods box and assumed the role of auctioneer. The bids went

higher and higher, as the sympathies of the pioneers awoke and expanded, till at last the sack was knocked down to a mill man at two hundred and fifty dollars, and his check taken. He was asked where he would have the flour delivered, and he said: "Nowhere—sell it again."

With his sack of flour auctions, Reuel Gridley became a national figure who traveled across the United States auctioning the flour. When he returned to Austin, he was in ill health, the silver boom was declining and his store was not bringing in enough to pay the bills. He and his family moved to Stockton, California. He died there in 1870 at the age of forty-one.

Churches

Austin boasts three historic churches: St. Augustine's, St. George's Episcopal and the Austin Methodist Church. Of the three, only St. George's Episcopal, built in 1878, is still in regular use as a church. There is a strange quirk about the design of St. George's: you are only able to ring the church's bell in the bathroom. Built in 1866, the Austin Methodist Church is being restored as a community center. St. Augustine's, built in 1866, is the oldest Catholic church in Nevada and is being restored as St. Augustine's Cultural Center. All three churches are listed with Nevada historical markers.

St. Augustine's church. *Photo by Bill Oberding.*

"St. Augustine's sits on Virginia Hill." Those words made me laugh the first time I heard them. Back in the day, notorious gangster Bugsy Siegel had a girlfriend by the name of Virginia Hill. Bugsy was perusing the evening newspaper in Virginia's posh Beverly Hills home when a few hitmen dispatched him to the hereafter. But that's another time and place. Speaking of Austin's Virginia Hill, it may not look like much to you until you start to walk up it, but it's steep—steep enough that it might seem familiar to anyone from hilly San Francisco.

Movie buffs, take note: if you saw the movie *Vanishing Point*, you saw St. Augustine.

Austin's Library

Austin's library is located in a building that served as Austin's bank from 1863 to 1962. It is the oldest bank building in the state of Nevada and is the site of two unusual bank robberies. In June 1933, Arthur Phillips devised an ingenious plan to rob the local bank. He climbed into the building through a skylight and lived there for three days while watching the banking routine and awaiting his opportunity to abscond with the loot.

It came at two o'clock in the afternoon, when the cashier went across the street for the mail. Alone in the bank, Phillips helped himself to $1,450 in the till and fled to where his accomplice waited in a car parked nearby. It might have been the perfect crime except that someone saw Phillips climbing through the window and running for his car.

Austin didn't take kindly to its bank being robbed. Twenty carloads of lawmen hit the trail in search of the criminal. Phillips was captured in the Reese River Valley several days later and suffered gunshot wounds to the leg, arm and hand. His accomplice made a clean getaway. Ashamed of his crime, he gave officers the fake name of Clarence Beal. Later, he would also inform them that he hadn't robbed the bank so much as burgled it. Either way, he was headed to prison for a long while.

Twenty-two years after Phillips committed his burglary, thieves used the skylight to enter the bank and make off with close to $4,000. Was it someone who'd heard of Phillips's earlier robbery? Or was it just a coincidence that the bank building was entered by a robber at the same location? Perhaps it was a design flaw and that is why it is no longer a bank. Besides, when was the last time you heard of thieves breaking into a library and making off with books?

GHOSTS AND HAUNTINGS

If the people of Austin all tell the truth, Austin is haunted by ghosts.
—Reno Gazette Journal, *August 7, 1879*

AUSTIN'S GHOSTS

Lander County's Old Courthouse in Austin

The old Lander County Courthouse in Austin was built in 1871, three years after Rufus Anderson met his fate at the end of a rope. This hasn't stopped Anderson from haunting the place, though. The ghostly Anderson is somewhat of a nuisance and enjoys moving pencils and other useful items around. Perhaps if he'd been executed in a better fashion, he may have moved on. But he wasn't and hasn't.

After being convicted of murder in the first degree, twenty-year-old Rufus B. Anderson of Austin, Nevada, filed a motion for a new trial. When that motion was denied, Anderson took the only option left to him: the Nevada Supreme Court.

There was no question that Rufus Anderson shot and killed Noble T. Slocum on May 5, 1868. The matter put before the Supreme Court was what Anderson's attorney considered to be errors on the part of the state. Unfortunately for Rufus Anderson, the Nevada Supreme Court disagreed,

finding no errors in the original indictment—nor did the justices find any of Anderson's other points of appeal valid. Rufus Anderson's luck had all run out. A new date was set for his execution. He would be hanged on October 30, 1868. In a time before executions were carried out at the state prison in Carson City, each county was responsible for conducting its own hangings. So Rufus Anderson was set to be executed in Austin in the county of Lander.

Located in the middle of Nevada, on the western slopes of the Toiyabe Range, Austin was only six years old and growing. Founded in 1862 as a result of the discovery of a rich vein of silver like so many other boomtowns, the city was prospering. According to local legend, silver was discovered in Pony Canyon when a horse kicked over a rock, and the rush began. On the other side of the state, the Virginia City Comstock silver rush was waning. The men who'd become fabulously wealthy took their millions and moved elsewhere. Those whose fortunes hadn't increased on the Comstock eyed Austin with interest. Many of them packed up and headed for Austin.

With more folks settling in and around the area, Lander County was created in 1864, and the town was incorporated that same year. Austin's population increased to nearly ten thousand, making it Nevada's second-largest city. It was only common sense that it be selected as the county seat of Lander. Unlike some of Nevada's other boomtowns, in which the precious ore dwindled away within a few years, Austin's silver held out for close to twenty years. In that time, the city flourished, and beautiful brick churches and buildings were erected. As the seat of Lander County, the rapidly expanding boomtown also needed a courthouse where official county business would be handled. A local man was hired to build the simple one-story courthouse; this was where Rufus Anderson would be tried and hanged.

Days before he killed Noble Slocum, Rufus Anderson made a fateful decision: he started carrying a gun. This had nothing to do with Slocum, though. Anderson was fighting with another man, and that anger seethed inside him until it spilled over one afternoon in 1868.

If anyone was ever in the wrong place at the wrong time it was Noble T. Slocum. On the afternoon of May 5, 1868, he happened to be visiting the Eggleston family when Rufus Anderson and his mother, Mrs. Zottman, also came by. Several other people were at the Eggleston house that day; Mrs. Zottman noticed Slocum immediately. He owed her money, and she meant to get paid. After a brief word with her hosts, Mrs. Zottman walked over to Slocum and asked when he intended to pay her for room and board and laundry. He ignored her. Someone suggested he might be hard of hearing, so she cleared her throat and loudly asked him for the money once more.

Lander County's Old Courthouse in Austin. *Photo by Bill Oberding.*

Finally Slocum spoke. "Didn't I work for Zottman?" he asked.

Mrs. Zottman admitted it was so, but times were hard and she needed the cash. "Surely, you don't mean to turn your bill in like that," she gasped.

"Oh, yes I do." Slocum said, looking her straight in the eye.

Rufus jumped up and stood between his mother and Slocum. "If you intend to treat my mother like this, Slocum, you are not a gentleman," he snarled.

Mrs. Zottman gently shoved her son aside. "Rufe, I will speak for myself." She turned to Slocum and said, "My husband did not support me, as you

well know. I need that money." He silently nodded agreement, but he would not pay her. Young Rufus was infuriated by what he saw as a slight to his mother.

"Mr. Slocum! You are not a gentleman and have not the principles of a gentleman about you, if you would treat my mother that way," he bellowed.

Slocum moved closer to Rufus. Shaking his finger in the younger man's face, he said, "By God, don't talk to me that way, Rufe."

Anderson stared coldly at Slocum. "Keep your hands off me."

The lines had been drawn. Eyeing each other angrily, the two men headed for the front door. Slocum lashed out at Anderson, who screamed, "Keep your hands off me…keep your hands off me."

No one wanted this trouble, especially Mr. Eggleston, who jumped in the middle of Slocum and Anderson. "I won't have any fuss here," he said.

It was too late. There would be no more talk. Rufus Anderson's temper was raging. Without a word, he pulled out his new pistol and fired twice at the unsuspecting Slocum. Hearing the shots, Mrs. Zottman came running to the door, "Oh my God! You will kill me."

Slocum dropped to the floor, dead. As his friends grabbed and disarmed him, Anderson stepped over to Slocum's lifeless body and kicked it. "Goddamn him!"

Rufus Anderson was taken to jail and would be tried for the murder of Slocum. Once the Nevada Supreme Court affirmed the lower court's decision, finding no errors, the new date was set for the execution. Anderson would hang at one o'clock in the afternoon on October 30, 1868. The night before the execution, a small scaffold was assembled and erected.

According to the *Daily Reese River Reveille* on October 31, 1868, "The scaffold was brought onto the ground after sunset Thursday evening and was put up at 7 o'clock yesterday morning. The spot selected was about five paces from the door of the jail, and was a small yard nearly 20 feet square, bounded by the jail, one end and side of the court house and a low bank."

Rufus Anderson had not been much of a religious man in his short life. But he was taking no chances with the hereafter; he asked to be baptized as a Roman Catholic just hours before his date with the rope. As the appointed hour drew near, Anderson quickly dressed in a new black suit. As he was led from the jail, he paused to say goodbye to two fellow inmates, who broke down sobbing.

At the scaffold, he knelt in prayer with the priest. Then, with a bone-chilling wintry wind blowing across the scaffold, Anderson faced the crowd and calmly said, "My friends, farewell, I forgive all who offended or wronged

me, and I earnestly ask the forgiveness of all those whom I wronged. I am about to suffer for my crimes, and I am going where I hope my condition will be changed for the better. I leave behind me a mother and sisters, and I ask that they be treated with justice and kindness as you hope for mercy hereafter. Farewell."

The death warrant was read to him, and he knelt in prayer. Standing, he said, "It is my request that Mr. Taber should put the halter around my neck. I see before me old as well as young men, and I beg them all to take warning from my fate. I am prepared now, and will endeavor to die like a man and a Christian."

He then calmly shook hands with the officers and friends who were present and stepped to the trap. His feet and arms were bound. "I commend my soul to thee," he whispered as the noose was slipped around his neck and his face covered by a black cape.

Then, something went wrong. The trap was sprung, and Rufus Anderson, rather than being hoisted into the next world, dropped to the ground with a *thud*. The crowd fell silent. Someone gasped and another screamed in horror as he was carried back to the scaffold and the noose again slipped around his neck. This time, he would surely swing. But he didn't. The same thing happened when the trap was sprung once again. Two failed attempts enraged the crowd. "This is butchery!" men roared.

Courtroom, Old Courthouse, Austin, Lander County. *Photo by Bill Oberding*

If not for the armed guards who stood nearby, the unruly crowd might have overtaken the scaffold and set Rufus Anderson free. Some of the men angrily demanded Anderson's life be spared after such a debacle. But a death warrant is a death warrant. After some deliberation, it was decided that the unconscious Anderson was just too hefty for the hanging to work properly. But justice must be met. And so Anderson was strapped to a chair; he would be hanged in a seated position. Before the deed was done, he awoke and asked for water. That request filled, the noose was placed once more around his neck and the trap dropped. The third and final hanging of Rufus B. Anderson was successful.

His body was taken to Carson City for burial. But they say that Rufus Anderson hasn't gone away at all. His ghostly presence has often been felt by more than one employee here at the old courthouse. In case you're wondering, those heavy footsteps, misplaced items and bursts of cold air are all the work of Rufus Anderson, who refuses to leave the building.

The Lynching of Richard Jennings

There is yet another story that might explain some of the old brick building's eerie activity. The lynching of Richard Jennings for the coldblooded killing of John Barrett on a cold December night in 1881 may have left Jennings feeling like he needed to haunt the building. Leaving his wife and several children behind in California, Jennings had come to Austin eleven months earlier to work in the mines. In that time, he made few friends. He was known to be mean and quarrelsome.

The *Daily Reese River Reveille* on December 13–14, 1881, reported the murder and the subsequent lynching:

> *We are again called on to record another fatal shot from which John A. Barrett, and old and much respected citizen of Austin, was almost instantly killed. Somewhere between 10 and 11 o'clock last night, Barrett was in the barroom of the International Hotel when a man by the name of Richard Jennings sought trouble with him when some angry words passed. The matter was shortly quieted down and quickly settled. In the course of 15 minutes afterwards, Barrett asked Jennings in a friendly manner to take a drink at the bar. Immediately following which, and while standing up against the counter, Barrett turned from Jennings to engage in conversation with another person when Jennings drew a Smith*

Left: Stove in the Old Courthouse; *Right:* Jail cell door of old Lander County Jail. *Photos by Bill Oberding.*

and Wesson's self-cocking revolver and fired three shots and either from the first or the second shot the ball entered Barrett's back immediately, under the right shoulder blade, striking the spinal cord. When the wounded man turned around, apparently paralyzed, being unable to speak, fell to the floor on his face, dying almost immediately.

Between 1 and 2 this morning Richard Jennings who shot and killed John A. Barrett the night before, was hung in front of the courthouse building. As near as we have been able to gather the facts connected with the hanging of Jennings they are as follows:

About half past one o'clock this morning a party of masked men numbering about 25 persons, well-armed, went to the courthouse and with a sledgehammer broke down a door from the main hall into a room between the sheriff's front office and the jail and on entering a gun or guns were levelled in close proximity to James Parrish's head, deputy sheriff who was

Flags from the window of the balcony at the Old Courthouse. *Photo by Bill Oberding*

lying in bed and who was held in abeyance, the key to the jail was then taken out of the Deputy Sheriff's pocket, and after an unsuccessful search for the key to the cell in which Jennings was confined, a sledgehammer was used, apparently one blow, when the key was found and the cell door opened and Jennings taken therefrom.

The article continued to describe the events in graphic detail—enough that you almost have to wonder if this was part of the reported lynching or if the reporter tagged along to report the news:

He was brought through the Deputy Sheriff's room with a rawhide lariat around his neck, and as he passed by the Sheriff's bed he cast a wistful look in that direction, evidently wanting to say something, but doubtless afraid to open his mouth, as he saw the inevitable crisis at hand. He was led to the front door by the leather necktie, and placed on the platform outside the main

front entrance to the courthouse building, and the other end of the lariat was thrown up to the portice of the second story—

Before he was drawn up, Jennings was heard to say, "Oh my God. Boys, I guess I deserve this."

So far as known to us, the act is endorsed by all. While of course, all good citizens oppose resorting to unlawful means in the punishment of criminals, yet for the protection of life and property, it sometimes becomes absolutely necessary to resort to Judge Lynch.

After that cruel sendoff, the ghost of Jennings could well be bent on revenge. Can you say that you blame him much?

EVP Session in a Jail Cell

Recently, I spent some time in one of the jail cells here at the old courthouse. Richard Jennings had spent his last moments on earth in one of the two of them, so why not try for some EVP? While being very careful not to use a phrase like, "Are you still hanging around," I used my trusty Samsung phone recorder to ask if he was still in the area. I asked if he would like to speak with me— it's a standard question. I waited. Next question: "Do you want justice for what happened to you or have you moved on?" If the latter were true, he wouldn't be responding. There was nothing scientific in my impromptu EVP session. Jennings didn't see fit to respond to me, but that's okay. Perhaps he had moved on. Perhaps he was still here but saw me as a nuisance. Either way, I was feeling depressed and glad to get out of there. But I'll be back.

Old jail cell at the Old Courthouse. *Photo by Bill Oberding.*

The Mysterious Death of Judge James Hervey Ralston

In its May 6, 1864 edition, the *Austin Star* reported on the funeral of Judge Ralston:

> *His body upon its arrival in town was taken in charge by his brother Masons, of which order he had attained the rank of Knight Templar. At an early hour yesterday, the members of the legal fraternity met at the court house and resolved to attend in a body the funeral of the honored deceased. The procession formed in front of the court house at one o'clock and, headed by the Austin brass band, followed by the Masons in regalia, members of the bar, firemen, hearse, the family of the deceased, citizens on horseback and in carriages, the cortege marched to the cemetery. This was the most imposing funeral that has yet occurred in Austin. The worth, position and high esteem, the melancholy circumstances attending the death of Judge Ralston, gave a solemn and universal interest to the occasion. After the interment the procession returned, marching to a lively tune, to the court house, and dispersed.*

But just how did Judge Ralston die? This was a question that his family was never able to answer. Born in Kentucky in 1807, the judge had enjoyed a colorful legal career before ever stepping foot in Austin. He became a member of the Illinois bar in 1830, and seven years later, he was elected judge of the Fifth Judicial Circuit. In 1839, he was the presiding judge in the Carthage, Illinois murder trial of William Fraim, whose defense attorney was Abraham Lincoln. In a trial that lasted one day, Fraim was found guilty of killing a shipmate in Schuyler with a butcher knife. Lincoln tried to have the judgement set aside and failed. Three weeks later, Fraim became Lincoln's only client to hang.

Abraham Lincoln would encounter James Hervey Ralston again when Ralston was elected to the Illinois Senate in 1840. After losing a bid for reelection Ralston reentered the military at the outbreak of the Mexican-American War in 1846. His wife, Jane, died one year later.

After leaving the military, Ralston made his way to Sacramento, California, and remarried. In 1860, the Ralston family was living in Virginia City. Three years later, in July 1863, Orion Clemens, acting governor of Nevada and Samuel Clemens's older brother, appointed Ralston as probate judge of Lander County. That same year, Ralston was elected to the Constitutional Convention as a Storey County representative. In November and December,

he attended the convention and helped to draw up the framework for the Nevada State Constitution.

But fate, as it always does, caught up. On April 28, 1864, Judge Ralston and a friend went out into the desert outside Austin in search of stray oxen. Unsuccessful in their quest, the two returned to town. For a reason known only to him, Judge Ralston decided to head to his ranch in Smoky Valley. The decision would cost him his life.

With the temperature soaring, he quickly became disoriented. When an Indian woman came upon him, she offered water and pine nuts. Delirious from the heat, he refused both. When word of his being missing got out, his friends hired trackers to find him. An Indian by the name of Oneweda led them to Judge Ralston's charred remains. He had found the body and burned it, he said, to keep wild coyotes from ravaging it.

His family would always wonder if something far more sinister had happened to him out in the desert. The judge was buried in the Calvary Cemetery at Austin. But all was not lost—the valley, in which he had gotten lost and perished, was later named Ralston Valley in his honor.

Like Rufus Anderson, who would be hanged four years after Ralston's death, Judge Ralston did not live to see Austin's fine new courthouse. Once a lawyer always a lawyer, so perhaps Judge James Hervey Ralston walks the halls of the old Lander County Courthouse in search of clients.

Cemetery and the Glowing Lady

Austin's cemetery has been listed in the National Register of Historic Places since 2003. The cemetery is five acres, split into four sections; it is located just outside town on either side of Highway 50. The Odd Fellows and Masonic sections of the cemetery are on the north side of Highway 50 and Calvary; the Catholic and citizens sections are on the south side. This is the high desert, and like many of Nevada's old cemeteries, there is no expanse of grass to be found here. The elaborate angel gravemarker of Mrs. L.W. Compton is unique in that it may be the only grave in a Nevada cemetery that is adorned by such a large angel headstone.

I have visited and photographed this old cemetery many times over the years and have yet to encounter anything ghostly. This doesn't mean there isn't something paranormal lurking in the cemetery, but I don't subscribe to the belief that cemeteries are any more haunted than other locations. Why should they be? There are just too many other interesting places for

Above: Austin Calvary Cemetery gate, Austin; *Left*: Angel headstone, Austin Cemetery. *Photos by Bill Oberding*

Austin Calvary Cemetery. *Photo by Bill Oberding.*

a ghost to haunt. The following story that a young woman shared with me at a ghost conference not so long ago was the first I'd heard concerning a ghost at the cemetery:

> *My sister's best friend had married and moved to Ely. We'd visited her and were on our way back to Reno. It was just turning dark. My sister was driving. We had just passed Austin and I was thinking that we'd soon come upon the old cemetery. Just before we did so, this glowing woman came out from the Calvary side and darted out onto the highway. She stopped in the middle of the road and seemed to be staring straight at us.*
>
> *"Slow down! Don't you see that woman?" I screamed at my sister, who didn't even slow down. I braced for impact. But there was nothing.*
>
> *"Quit being so melodramatic, it was only pogonip* [a Native American word for a dense frozen fog of ice crystals that occurs in many parts of Nevada]. *"*
>
> *"I know what I saw! And it wasn't pogonip," I insisted.*
>
> *"Well then—where is she?" my sister asked me as we sped on past the cemetery.*
>
> *I looked around to see if I could see the glowing woman in the cemetery but I didn't see anything. We went by there more times I never saw her again. But I know what I saw that night and it must have been a ghost.*

Tommy at the International

The International Hotel began life in 1859 in Virginia City about 180 miles west of Austin. In 1863, the hotel was disassembled and the lumber hauled to Austin, where it was rebuilt piece by piece. Everyone around knows the place to be haunted. There is always the possibility that a ghostly presence hitched a ride with the lumber at that time. But most people think Tommy is the only resident ghost here at Austin's International Hotel. He either likes you or he doesn't. And if Tommy doesn't, he might just appear and order you to leave the bar. And when a ghost tells you to go, you go. Tommy didn't like a former owner of the hotel, and just to make certain the man was aware of this, he'd sometimes push the man down the stairs.

Back in the 1970s, Tommy was alive and well and living upstairs at the International. Then he got sick. After he finally died of natural causes, strange things started to happen. His ghost decided to stay on. And plenty of people have encountered him. Tommy's been known to greet those he knows warmly with an unmistakable "Hello."

Then again, he can be ornery. A local Austin resident was quoted in an article in the July 11, 1999 *Reno Gazette Journal*: "There was a local guy a few years ago. There was just him and one other customer playing pool. He [the

International. *Photo by Bill Oberding*

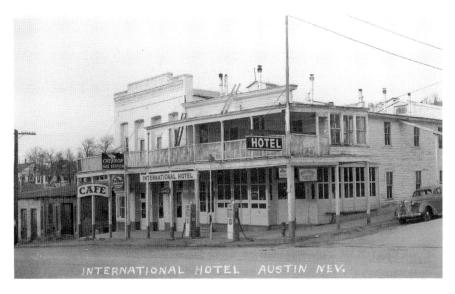

International from an old postcard. *Author's collection.*

bartender] was lining up his shot. This voice came out of the back by the fireplace. It said, 'You're going to miss.' He missed." Was it Tommy? I'm betting that it was. And he's got the entire upstairs area of the International Hotel to himself. The old hotel closed the upstairs to guests, and it now serves as a restaurant/bar only.

There could be other ghosts hanging out at the International Hotel. One of them may be John A. Barrett, who was shot to death at the International Hotel bar in December 1881 by Richard Jennings. Jennings paid for his crime when he was lynched three days later.

If there is another ghost in the building, Tommy's not telling. Perhaps he enjoys the notoriety of top billing too much to share it with another.

Over lunch, a ghost hunting friend of mine was telling me of a recent stop at the International in Austin. "What about the ghost? Did you see anything?" I asked.

"Not a thing," he answered. "The bartender scoffed about the idea of ghosts, so I didn't pursue it." I nodded knowingly. Some people just don't like talking about ghosts. Perhaps the idea frightens them. Then again, they may think that anyone who believes in the existence of ghosts is a bit odd. "The chorizo sandwich was out of this world...the best I've ever eaten," he said. Wonderful! But unless it was made of chicken chorizo (which is highly doubtful), I won't be trying it.

A Ghostly Principal

Schools are often haunted. And more often than not, it's a student who decides to stay in school forever. Things are different at the old Austin High School. The school was built in 1929, a modern marvel in which young minds were opened and lessons were learned. Year after year, the graduating class grew smaller as families picked up and moved on. But not everyone did. Generations of Austinites can say that someone in their family tree went to the old Austin High School, the old alma mater—but what is a school without a ghost or at least a legend? Austin High has one.

No one remembers when or how, but the story goes that long ago (probably sometime between 1929 and the 1960s), the school principal, consumed by his own secret sadness, grew increasingly despondent each passing day. One Friday night, he decided to take his own life. He waited until everyone had gone home and he was alone in the building. Then he went to his office and hanged himself. Whatever troubles he was hoping to avoid, it didn't work.

Mysterious footsteps and other strange noises are common occurrences once the students have left and the building is empty. One person who's been in the building late at night described the noises as "creaking." Now, we could look at this skeptically. After all, old buildings do creak. But it's just as likely that as it is the ghostly principal. Then again, we know that nothing will keep a ghost here on our earthly plane more than unfinished business. Is it possible that he had lessons to grade, schedules to make and assignments to write? Or does he regret his rash decision? I'm betting it's regret that keeps him walking these hallowed halls.

EUREKA'S GHOSTS

Imagine Virginia City without the tourist trappings, and you've got Eureka.
—Reno Gazette Journal, *March 28, 1986*

The Haunted Opera House

The Eureka Opera House was crowded its utmost capacity last night by our people who assembled for the purpose of hearing Lew Johnson's original Jubilee singers.
—Eureka Leader, *May 15, 1884*

There are only three historic opera houses remaining in the state of Nevada. There is Thompson's Opera House in Pioche, Pipers Opera House in Virginia City and the third right here in Eureka. Bigelow's Opera House was destroyed by fire on April 19, 1879, when a lamp exploded during the early morning hours. The windswept fire destroyed a large portion of the town. The following year, Eureka Opera House was built at a cost of $80,000 at the same location where the fire-ravaged Odd Fellows Hall had stood. Fire was a very real concern to the town, which had been ravaged by other disastrous infernos, but there would be no such worries for the new opera house. The November 11, 1880 edition of the *Eureka Daily Sentinel* proudly proclaimed:

> *The building is, according to the plan of work now being carried on, to be thoroughly fireproof, built with masonry (volcanic tuff) walls, brick and iron front, and slate roof. From the basement to dome the new theatre will be furnished as none of the class have ever been in Eureka. Its arrangement is pronounced to be first-class, for ventilation, for heat, for means of egress in case of fire, and in fact for a thousand and one reasons it is bound to be a beneficial and permanent monument to the memory of those who have erected, and who will so soon elegantly furnish the same for the edification of our people.*

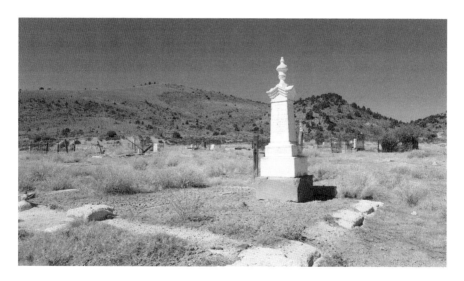

Eureka Cemetery. *Photo by Bill Oberding*

Another view of Eureka Cemetery. *Photo by Bill Oberding.*

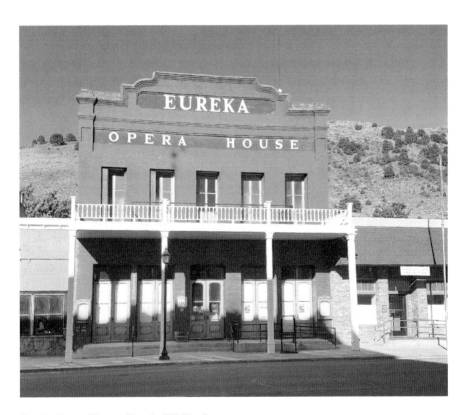

Eureka Opera House. *Photo by Bill Oberding.*

Indeed, Eureka's opera house is much smaller than the aforementioned Pipers and is still used as an auditorium and cultural center today. In 1994, the opera house was restored to its former glory. Country/western singer Eddie Rabbitt entertained those who attended the grand opening.

There is always a sense of wonderment surrounding old opera houses and theaters. This is especially true of the Eureka Opera House. Think of all those festivities, plays, dances and the music that happened here. Surely some of these have left an indelible mark here. The performers certainly have. Take a peek behind the stage and you will see the theater's tradition. Every performer is encouraged to sign the wall with his/her name. And they do. Two autographs on the wall are those of singers Eddie Rabbitt, from 1994, and Juice Newton, who appeared at the opera house in 1997.

There is even a glass-enclosed display of Lola Montez's beaded and crocheted shawl. Ms. Montez died several years before the opera house was built, but this isn't to say that she didn't perform her notorious Spider Dance somewhere here in Eureka—she probably did.

Times change, and with the advent of silent movies, the opera house changed direction. The first movie was shown in the opera house in 1915, and the opera house was renamed the Eureka Theater. Movies were shown in the theater until the late 1950s. The old building quickly fell into disrepair. If not for the community's efforts, the Eureka Opera House might have ended up nothing but a pile of rubble like so many other historical buildings. Once the

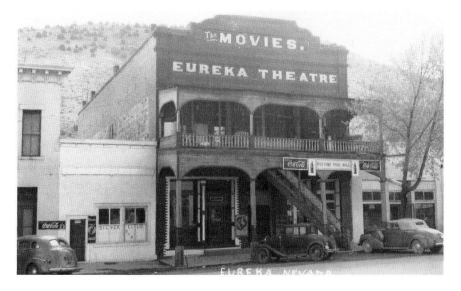

Eureka Opera House from an old postcard. *Author's collection.*

County of Eureka acquired the opera house, more than $2 million was raised for its renovation.

At the opera house, they will tell you that only one person has died in the building. They believe there is only the one ghost, known as "Mormon Joe," in residence. But we ghost enthusiasts know that a ghost can wander in from anywhere and decide to take up residence. That might explain why some investigators believe there are a few ghostly children haunting the Eureka Opera House in addition to Mormon Joe.

Of all days to die, Joe Barker (Mormon Joe) perished on Halloween 1896. Barker was a tailor who owned a shop on the ground floor of the opera house beneath the stage. Trying to stay warm, he took embers from a bonfire across the street at the courthouse back to his shop for a little fire. All was well, until he fell asleep. Uncontained, the fire raged, damaging the front of the opera house and killing Joe, who died of smoke inhalation.

An unexpected death can give rise to a ghost. Perhaps that's why Joe stays on at the Eureka Opera House. Some have seen him wandering throughout the building, seemingly unaware of others, his attire period dress. And like most ghosts, he gets the blame for any and all strange and unexplained noises. Is the ghostly Mormon Joe responsible for all of it? No, said a psychic who felt the presence of children while visiting the opera house.

Some believe that that the presence of a ghost always lends a negative aura to a building. This is simply not so. One need only visit the Eureka Opera House to dispel this belief. I was speaking at a paranormal event presented by Eurekan Adam Bogart and couldn't wait to visit the opera house where the event would take place. The first thing that struck me as I entered the building was how light and positive it felt. As I walked through the opera house, I couldn't help but notice its artistry and the heavily polished wooden floors of a bygone era. But it was the colorful olio-style stage curtain that held my attention. Created in 1924, this curtain features a large painting of Venice surrounded by ads from local businesses long defunct. This curtain replaced the opera house's first curtain, which was destroyed by an overturned kerosene foot lamp in 1923.

The question on everyone's mind was what we might encounter during our ghost investigation of the opera house. It was mid-June and a warm night for Eureka. We met at the front door and broke up into small groups. My husband, Bill; Petra Brandt, founder of Reno's preeminent ghost investigation team, Ghost Posse; and I were among those who gathered in the basement, where the ghostly Mormon Joe is said to hang out. We would do a few EVP sessions, which involve asking questions and

Interior view of Eureka Opera House and stage curtain. *Photo by Bill Oberding.*

hopefully recording answers from the spirit world. It just so happened that some of the locals and their children had caught ghost hunting fever and were eagerly joining in the quest. As we entered the darkened room, the children were leaving it. "That ghost doesn't like us," one of them told us.

How odd, as these were some of most well-behaved children I'd met. I suppose there is no accounting for ghosts, as well as their likes and dislikes. During the session, I made a point of asking, "Why don't you like those kids?"

Later, as I played back the recordings, I heard one faint word: "Liar!" or perhaps it was "Fire." I listened several times and realized that it could be either. Perhaps Mormon Joe was telling me that I was lying and he did actually like the children. Or he was reliving that horrible moment when he perished here at the Eureka Opera House. Although I got no children on the recordings, I think that there are a few ghostly kids enjoying the hereafter here at the opera house.

My friend Jeff Frey of the RASS ghost hunting group was so intrigued with Eureka's ghostly possibilities that he organized a group ghost hunt in Eureka. As these things sometimes do, plans fell through. Cancellations were made, and on the day of the trip from Reno to Eureka, Jeff found himself alone except for his friend Bruce. Undaunted, the two men headed for what promised to be some great ghost hunting in the little town of Eureka.

Once in town, they caught up with Eureka's paranormal guru Adam Bogart and planned their investigations. First up was the tunnel. According to Jeff, it was incredible, although they didn't stay too long there. In the café, they set up video cameras and other equipment and waited. For some unexplained reason, the video portion of the camera stopped working halfway through the night. Was it a ghost playing with the equipment?

At the opera house, Jeff and Bruce got the best activity and evidence. "I saw a shadow person in the kitchen area," Jeff said proudly. "And a large black mass, maybe it was Mormon Joe…in the hallway where all the names are on the walls? I got a very clear EVP that said 'flashlight.' Mormon Joe again, I don't know."

Ghosts of the Jackson House

When it was built in 1877, the Jackson House advertised that it was "the only fire proof hotel in eastern Nevada." This was of special importance due to the devastating fires Eureka was often subjected to. The fire of 1879 destroyed much of the downtown area. But the "fireproof" Jackson House and the saloon next door remained standing.

The Jackson House is a charming old-world inn in the historic area of downtown Eureka. Even those who don't seek out ghosts have experienced ghostly phenomena at the Jackson House. According to Adam Bogart of Eureka Paranormal, there are at least twelve ghosts in residence at the Jackson House. And they are an active bunch.

Some who've stayed here claim to have seen and heard ghostly children who scamper up and down the hallway. The children are sometimes accompanied by an older woman who seems to be their governess. Recently, a housekeeper reported finding tiny footprints on the carpeted stairs after vacuuming.

Several ghost hunters have come to Eureka and investigated the Jackson House over the years. Slamming doors, flickering lights and laughter are some of the ghostly occurrences at the Jackson House. The resident ghosts are not above a little mischief. Guests are sometimes locked out of their rooms, only to discover that there is no earthly reason for this.

One person reported that after taking a shower, she stepped out to find the words "I'm watching you" written on the foggy bathroom mirror. Some have reported that upon entering the Jackson House, they have encountered a young man and woman. The couple seems friendly and

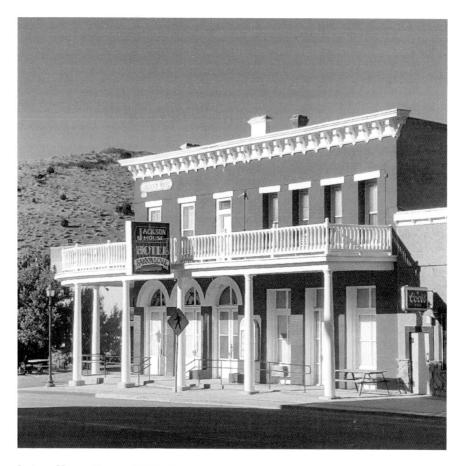

Jackson House. *Photo by Bill Oberding*

welcoming. Not so, though, for the ghost they call "the Nomad." The Nomad moves from one haunted place in town to another. But the Jackson House seems to be his favorite spot. Fair warning: he doesn't like ghost hunters. If he happens to be on the premises when you visit, you'll know it. He might just scratch you. For those who might be thinking he's a demon, think again. The Nomad is just a mean ghost that enjoys frightening people and making his presence known. He happens to be very territorial, wherever he is hanging out.

A ghost hunting friend of mine recently spent time at the Jackson House with her husband. While she enjoyed the place immensely, even doing impromptu ghost hunts and EVP sessions, her hubby did not. There was something about the Jackson House that he truly disliked. He does not share

his wife's enthusiasm for things that go bump in the night and likened the Jackson to a "hellhole." While I know him to be a nice guy, I am betting the Jackson House ghosts took umbrage at that statement and that the dislike was mutual.

The Haunting of Lee Singleton

If anybody in Litchfield County, Maryland, misses a man or loses a friend named Lee Singleton, who was born in 1841, went to the wars on the Southern side, followed the Pacific Railroad out West to the end, became a miner in Culver Canyon, near Eureka, they may now know that this man or friend is dead.
—Seymour Weekly Times, *June 30, 1877*

Imagine sitting alone in a cabin lit only by the light of a kerosene lantern. Outside the wind is howling. You want nothing more than to write your confession, unburden yourself of the terrible guilt and then die. This is the strange saga of Lee Singleton and his confession. It's a story well known around Eureka. Singleton and the ghostly retribution of his victim might never have come to light if not for the curiosity of one man.

Alone in his shanty, Singleton sat down and wrote a full confession for the murder of John Murphy and of the ghostly aftermath he had faced—justice, perhaps. Nonetheless, it drove Singleton to commit suicide once his confession was written and his conscience clear. And it might have ended there except for the man who happened upon the cabin and discovered Singleton's skeleton leaning against an old bunk.

He called a friend to help him bury the remains, and that was the end of that. A few years later, a hunter discovered the old cabin and walked in to get a closer look. That's when he discovered the small copy book sticking out from under a board of the bunk. The pages had been written by Lee Singleton, and aside from his name and other pertinent information, the book contained a full statement and confession for the killing of John Murphy. Singleton's statement appeared in the April 15, 1877 issue of the *Eureka Sentinel*:

> NOVEMBER 17, 1876
> *After four years wandering here I am back in the old cabin that I helped to build six years ago. Surely that six years of hell ought to go a little way toward the final reckoning, but it can't be any worse in the other world than*

it is here and I will give it a trial anyway. Perhaps I will meet John there and he will take the curse off me. I wonder if anyone will ever read this or whether it will lay and rot alongside of me? It makes little difference, but it seems as if I could lay down easier if I could write down what I have dared not to whisper since I done it. My name is Lee Singleton. I was born in Litchfield County Maryland, in 1841.

I lived there until the breaking out of the war, when I entered the Southern army, and served until the close of the war. I was wounded twice; once at Yorktown and again at the siege of Petersburg. Both my parents died; and after the war was over I came west and followed the Union Pacific railroad until it was completed. I then went to White Pine, and in 1871 to Eureka, where I went to work as a feeder at the—furnace. My companion, John Murphy was very overbearing and insulted me on several occasions, but as he was a much stronger man than myself I took no notice of it until one day he struck me. He did not know that he signed his death warrant with that blow, but he did. I never forgot him for it, although I did not retaliate at the time, but kept on working my shift as though nothing had happened. Murphy often taunted me with being a coward, and it was with the utmost difficulty that I could restrain myself from striking him down with a shovel, but I kept my temper and consoled myself with the thought of the terrible vengeance I would wreak upon him.

While feeding the furnace the thought often came to me that it would be an easy matter to stun him with a blow and throw him into the stack, and I knew that if it was once accomplished that no one could ever detect any traces of the crime. The principal difficulty was the continued presence of the ore wheelers, but as they worked ten hours and quit at six o'clock there was an interval of an hour, during which me and Murphy were alone, save the occasional visit of the night boss. I had to wait nearly two weeks before the shifts changed so that we came on at the same time. When the opportunity finally presented itself I stepped behind him and struck him a blow on the head with my shovel as he was stooping to get a scoopful of charcoal. To drag him to the feed hole and throw him on the charge, was but a moment's work. I do not know whether he was dead or only stunned, but it made little difference, as the furnace would have suffocated him in a moment. By working hard I succeeded in covering the body with ore and charcoal, and as the charge in the furnace sunk he was soon out of sight, and it would have been impossible to find the least traces of him. This work occupied about fifteen minutes, and by that time the night boss came along, and I commenced growling because John was not attending to his work. He hunted around for him and asked me when I had seen him last.

I told him that he had put on his coat and hat and gone out, complaining that he was sick. The boss, not being able to find him, helped me out for the balance of the shift, which was only half an hour. I calculated that the body would reach the mouth of the towers in two hours, but I did not dare to linger around the furnace.

Remorse

After my work was done I went to my room but could not sleep, and I felt relieved when the sixteen hours were up and I had to resume work again. I never have forgotten those eight hours. It seemed that every shovelful of ore that I flung into the feed-hole struck on his body and that the bubbling of the blast took to itself speech and upbraided me for my cruelty. When burring-out time came I went to the front of the furnace, it was him that I was stirring up and raking out instead of the clinkers of iron. My reason told me that the fierce heat had consumed every portion of him, and that what had not gone off into the fumes had run out of the front and was now a component part of the slag-pile; but a hallucination fixed on my brain and I saw him materialized at every part of the furnace where my work called me. I got such a mania for looking into the feed-hole of the furnace that I soon became leaded and incapacitated from further labor; and on my recovery I could not procure another situation, as the foreman seemed to have some suspicion that I was accountable for John's strange disappearance.

I then went into the charcoal business, with two other men, built the cabin in which I am writing this statement. We burnt coal here for two years, when the wood becoming exhausted, I took my share of the profit, $2000 and went East, first paying the furnace a visit, which I had done before whenever I came to town. I left Eureka and went to Wisconsin to the lead mines. I could not stay away from a blast furnace, and whenever I saw one, there was John right in the hottest place, seemingly taunting me for killing him. From Wisconsin I went to Pittsburg; from there to Salt Lake; and finally after four years wandering came back to Eureka. I hardly got off the train bent my footsteps to the old furnace. I wanted one more look at it and then I had determined to end my miserable life.

The Furnace

It still stood on the same spot, although other ones had been built close to it. The works were not running and for two weeks I used to go every night and wander around the premises. I calculated as to the exact place where John fell, the boards that I drew the body across and the identical feed-hole

that I threw it into. Finally the watchman drove me away and I bought an ounce of laudanum and walked over the mountains until I came to the old cabin. As soon as I finish this I shall take the poison and lay down in the bunk. I don't suppose that anyone ever passes this way, and I shall probably lay here and rot, or the vermin will feast on me. I cannot go to a worse hell than what I have been in for the last six years. If anyone finds this statement they can verify the truth looking over the books at the smelting company, and they will find mine and John Murphy's name on the payroll, and if R.M. Wallis is still in Eureka, he will remember the fact of John's disappearance, for he was the night foreman at the time.

LEE SINGLETON

Alone in the cabin, Singleton finished his missive and drank his poison, but he was not to rest in peace. After tormenting his killer, John Murphy moved on. Apparently, Lee Singleton wasn't so fortunate. His lonely apparition is said to haunt that area of the canyon where his cabin once stood. Whenever he is encountered, the ghostly Singleton seems dazed and confused.

Maggie, Angel of Mill Canyon

Nevada is dotted with ghost towns. Abandoned and forgotten, they are evidence of the state's early-day boom and bust periods of mining. Located at the foot of Mount Tenabo, Cortez, about one hour outside of Eureka, is just such a ghost town. Like other ghost towns, only a few remnants remain of what once was a thriving little town. There is also the ghostly Maggie, a spirit that wanders a lonely path from her shack in Mill Canyon to Cortez.

Born into slavery in Louisiana on May 13, 1842, Maggie was no stranger to heartache and hard work. With the 1863 signing of the Emancipation Proclamation, Maggie was free to pursue her dreams. She came west to the booming area of Mill Canyon, staked out a small mining claim and opened a boardinghouse. And she prospered. Her beauty and her kind heart were known far and wide. In an article in its July 14, 1957 issue, the *Nevada State Journal* referred to her as the "Black Angel of Mill Canyon" because she was always willing to help a miner who was down on his luck and hungry.

Romance came into her life in the form of H.L. Smith. Her mine, the Rhoda, was doing well. And as Mrs. Smith, Maggie continued to enjoy

wealth and status. According to legend, whenever the lovely Maggie went to Eureka to do her shopping, she wore a fine silk gown and traveled in the finest of carriages. Tragedy struck in 1890 with the death of her husband, who was buried at the Eureka Cemetery. The following year, she married Mr. Johnson, who died two years into the marriage. He was buried one space from H.L. Smith. Maggie, when she did die, would lie between them in eternity.

Like Cortez and Mill Canyon, Maggie saw her luck start to change in 1893. The silver was gone, and men were leaving the region. She would stay and eke out a living in her mine the best way she could. Maggie died alone and destitute in August 1924. Although she is buried in Eureka, it's said that she still walks the eight-mile trail from Mill Canyon to Cortez. Happily chuckling at the vagaries of life and death, Maggie is, they say, the happiest ghost anyone will ever encounter.

Because this was part of her daily routine for so many years, perhaps this isn't a true haunting at all but rather an event that imprinted itself on the surroundings and is residual—a place memory haunting.

Owl Café

While traveling America's Loneliest Road (Highway 50), be sure and get your free "I Survived the Loneliest Road in America" passport and have it stamped at visitors' centers along the way. It's fun for kids of all ages.

Okay, so I'm a ghost hunting foodie. And after that confession, let me tell you about the ghosts and the chicken strips at the Owl Café (or Owl Club Bar and Steakhouse). As a historian, I think it is important to find a reason that a ghost might stay at a particular location. The Owl Café has at least two. The building that houses the café once housed the notorious Tiger Saloon. It was here on September 1, 1876, that Bulldog Kate Miller got into a screaming match with fellow prostitute "Hog-Eye" Mary Irwin. Judging by these monikers, the two prostitutes probably weren't the most attractive women ever to enter Eureka.

The screaming continued, and the argument escalated. One of them decided to take the fight to the street. There Mary Irwin pulled a knife and put an end to all of Kate Miller's earthly problems. Mary Irwin was taken to jail and Kate Miller to the morgue. This didn't end the sorry saga of Kate Miller though. She was buried in a lonely spot out at the Eureka Cemetery. Her determination to stick around at the Tiger Saloon was reported on in the

Left: Bill Oberding with his "Loneliest Road in America" passport. *Photo by the author.*

Below: Owl Café sign. *Photo by Bill Oberding.*

Pioche Daily Record, which told of Miller's disembodied voice and apparition having been seen and heard at the saloon.

Another long-ago murder upstairs in what was once the saloon is probably the reason for at least one ghostly resident here at the Owl Café. On May 2, 1880, Billy Martin and John Brent were drinking together at

the saloon. The more they drank, the more braggadocio they displayed. Neither man was afraid of the other. Martin had ridden with the sheriff's posse that had gone out to a canyon at Fish Creek on August 18, 1879, and killed in cold blood five men who worked the charcoal ovens. On this night, karma caught up with him. As Brent boasted, Martin jumped up and started shooting. Unfortunately for him, Brent was faster…and Martin was dead.

I think it's important to eat something before ghost hunting. One reason is that a growling stomach can interfere with EVP recordings. But who am I kidding? I like to eat anytime. Before the night's investigation, I anxiously scanned the Owl Café menu. What did it have good to eat? I had been told that the steaks are *muy sabroso*, but I consider myself a connoisseur of chicken strips. And that's what I wanted, with tater tots. I've eaten some mediocre strips and I've eaten some fabulous strips. None compares to those at the Owl Café. Don't take my word for it. The next time you're in Eureka, check them out for yourself.

Haunted Tunnels

Nothing will set a ghost hunting heart aflutter like the words "haunted tunnels." The haunted tunnels under the old café will not disappoint. Rich McKay, owner of the building and the tunnels, took me and Bill on a tour during daylight hours. Above us, the temperature was heating up and pushing toward ninety-plus degrees. Yet it was comfortably cool down in the tunnels. These elaborate tunnels are rumored to have been built by Chinese immigrants. Nevada governor Reinhold Sadler used the tunnels when he walked from his residence to his business when snow was piled high on the streets. Later, prohibitionists and drug runners hauled their illegal products through the tunnels.

Zak Bagans's *Ghost Adventures* visited the tunnel and filmed an episode here. At a specific spot in the tunnel, I stopped and asked Rich if anyone else had said anything about this spot. "Aaron [Goodwin] did," he answered. I know the rules as well as anyone else who's ever filmed with Zak Bagans—no talking about what they did or didn't find until the episode airs. It hadn't, and Rich wouldn't. By the time this book is printed, the Eureka episode will have aired, and we will all know what Aaron found in the tunnels. My guess is a not very friendly spirit, but then again, prohibitionists and drug runners probably aren't the friendliest sort anyway.

Café sign outside the tunnels. *Photo by Bill Oberding.*

In its previous incarnation, the café above the tunnels was a Chinese restaurant. Imagine finding a little Chinese restaurant at the end of a long haul across the Loneliest Road in America. The possibilities are enough to excite the taste buds. But not so fast—the owner died and the restaurant was closed. Sometime later, someone came in and started growing marijuana in the tunnels. Gardening in the dark tunnels hardly seems conducive to a successful crop, but it must have worked—right up to the time that the pot operation was discovered and arrests were made. An empty Chinese restaurant with a smiling, dust-covered Buddha beckons. I wonder what the ghosts made of that.

Cemetery

The town of Eureka once boasted that it had more cemeteries than any other town in Nevada. While that may not be true when compared to Virginia City, there are a lot of them. Don't come to the cemeteries looking for hauntings and ghosts. You probably won't find any. However, if you want to spend an interesting afternoon exploring old cemeteries, this is the place. Some of the headstones and the people who reside here are long forgotten. Where once the cemeteries were some distance from town, progress has changed all that; while standing in one section of

Left: Eureka County Cemetery sign; *Below*: IOOF Cemetery. *Photos by Bill Oberding.*

the county cemetery, you are not so far from the front doors of a row of mobile homes.

Bill and I are members of the IOOF. So naturally the old Independent Order of Odd Fellows cemetery is one of our favorites. With the weathered old fences that surround some of the graves, it is more picturesque than the Eureka County Cemetery. While here, it won't take you too long to discover that like so many other old Nevada mining towns, there are more residents here in the cemeteries than living in the town itself.

Ghost Hunt: The Garage

Ghost hunters are a breed apart. One thing about us is certain: we will investigate any place that is thought to be haunted. The garage in Eureka is one of those places. A group of ghost enthusiasts was gathered in Eureka for Adam Bogart's Eureka ParaCon. Adam is proud of his town, and he put on a fun event of varied speakers, a lively ghost walk and, of course, several unique locations to look for lurking ghosts.

Bill and I joined the investigation of the garage the first night. The location has seen many different owners and has been used for just as many different business endeavors. It was first used as a boot- and shoemaker's shop. Next it was a livery stable, and from the 1940s until the 1970s, it was a gas station and a garage. There is a gas station still operating on the corner next to the old garage.

As we began the investigation, I wondered if my imagination was running away with me in the darkened old building—or was it really haunted? I roamed through the cluttered garage and decided that it was probably a little bit of both. While Bill took photos, I tried for some EVP.

The equipment being used by the group included dowsing rods, cameras, EMF meters, recorders and the spirit box. The consensus seemed to be that the lingering spirit was that of a former owner or an employee of the garage. Questions followed in that vein: "Where you happy working here?" "My car battery is dead; can you fix it?" "What kind of guarantee do you offer?" "My car needs new tires."

I suppose it does happen, but can you imagine haunting your workplace in death? I can't. Still, I joined in with the questions: "How much for a new radiator? Does that include the installation?" My knowledge of car parts is limited, but I do know about radiators, having been on the road with Bill when ours sprang a leak and overheated a number of years ago.

My recorder was counting down. The spirit box was squawking. You have to have an ear for it—I don't; it all sounded like gibberish to me. Still, we tried. "Did you hear that?" Someone heard something in the spirit box. We all moved in closer to it. It was well after midnight. We'd been on the road since 7:30 a.m. that morning. Bill and I were beat. Unlike in larger cities, there is no light pollution here in Eureka. Under skies so clear we could see the Milky Way, we walked back to the Sundown Lodge, where we were staying. Don't try that in a big city.

"Do you think it's haunted?" I asked Bill.

"Could be," he said. "The EMF was throwing off some high readings… but with all that stuff in there it could be nothing."

"Yeah," I agreed. "But it isn't someone who worked there."

He chuckled. "I know." Later, we listened to our recordings. Yes, we got no evidence. And that's not uncommon. No one walks into a casino and wins the megabucks first try—in fact, it's rarely won. So it is with evidence of ghostly activity.

Colonnade Hotel

The Colonnade Hotel was built in 1880. For the next one hundred years, the building would see a succession of owners and be used for many purposes. One of the more colorful is its rumored use in the making of illegal whiskey during Prohibition. Some Nevadans paid little heed to Prohibition and continued making, selling and partaking of illegal alcohol. As the story goes, the whiskey that was made at the Colonnade Hotel was transported across the tunnels to other locations in town. During this time, Dr. Leighton Ray kept an office at the Colonnade Hotel. So did other doctors who came afterward, such as Dr. Hall and Dr. Todd in the 1950s. The Colonnade also served as a location for banquets.

Colonnade. *Photo by Bill Oberding.*

Today, the Colonnade Hotel is a private residence. Although owner Mike Popovich has had no paranormal experiences himself, he told me that those who've investigated the old building claim to have heard footsteps throughout the building. And there is the strong odor of burning wood present.

ELY'S GHOSTS

Ghosts in White Pine County

The ghost town of Hamilton is located in White Pine County, an hour or so out of Ely. Depending on what source you are reading, there were anywhere from twelve thousand to thirty thousand people living here during the town's heyday. They came to mine the silver that was discovered in 1868. When the silver ran out, so did most of Hamilton's citizens. That was typical of so many of Nevada's boomtowns. The town was all but a deserted ghost town when someone, unnamed by the newspaper, reported encountering ghosts at Hamilton. The following story of that encounter appeared in the January 9, 1879 issue of the *Eureka Leader*:

> *They have a genuine sensation in Hamilton at one of the deserted hostelries that marks the decaying fortunes of pogonip. Mysterious sounds are heard there after nightfall, not exactly like the tread of a no. 1 boot, but ghostly footfalls, the echoes of the pattering walk of denizens of Hades. Our imaginative informant states that on Christmas night a company of spooks surrounded the table in the dining room, disposing of a phantom dinner. The board was spread with imaginary turkey, fancied roasts and hallucinated* blanc mange, *while transparent waiters, through whom the dishes they bore were plainly visible, were bringing the wrong order to the wrong man just as natural as life. There was a ghostly clerk in the office, but he did not see any of the guests settling their bills.*
>
> *Some of the people were strangely familiar, and they could be recognized as a portion of those who lived on Treasure Hill in the bright days of '69. Passing around to the rear of the house he escaped a phantom valise being lowered by a phantom rope, but when he went to grasp the article it vanished into thin air.*
>
> *The ghosts of Christmas just passed were holding high revel and their festivities contrasted strongly with the deserted appearance of the rest of the town. The light that shone forth from the windows gave forth a pale blue glare, and as the stroke of twelve sounded forth from an adjacent clock the place was once more as still and silent as ever. It would be unjust to charge upon the few who yet remain on Treasure Hill any large indulgences in egg nog on that night, but it is about as reasonable a deduction from the tale as can be reached on present information.*

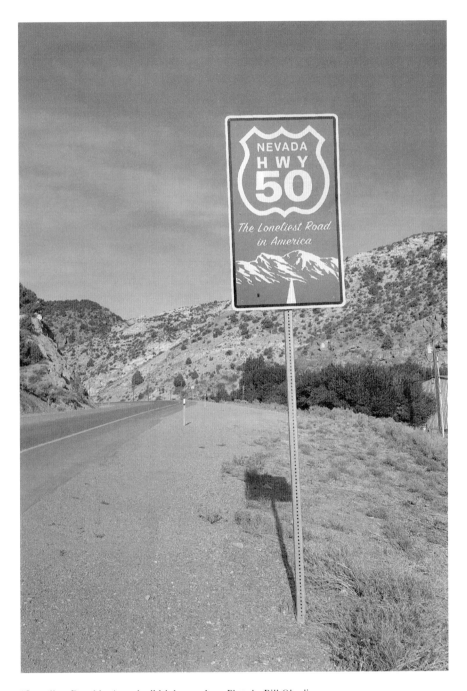

"Loneliest Road in America" highway sign. *Photo by Bill Oberding.*

In 1903, Nevada began executing those under sentence of death at the state prison in Carson City. Up until that time, they were executed in the county in which the crime had been committed. So it was that on New Year's Eve 1886, seventy-year-old Edward Crutchley became the first man executed in White Pine County when he was hanged for the murder of John Howlett the previous spring. He rests, hopefully, at the small Hamilton cemetery known as Mourners Point.

The scenic drive to Hamilton off Highway 50 is well worth taking, provided the weather is cooperating.

Time Slip Ely

In August 1901, two English schoolteachers, Charlotte Anne Moberly and Eleanor Jourdain, visited Versailles. There they decided to go see the gardens of the Petit Trianon, but they got lost along the way. What they experienced as they wandered the area was remarkable. According to Moberly and Jourdain, they began to feel out of sorts and encountered people in old-fashioned clothes using antique farming equipment and tools. While trying to find their way, the women came upon a woman they later believed was the ill-fated queen Marie Antoinette.

When they finally reached the Petit Trianon, they were once again back in their own time. Moberly and Jourdain were convinced that they had somehow traveled back in time, seen and talked with the ghosts of long-dead people. Using pen names, they co-authored a book about their experiences entitled *An Adventure* in 1913.

Moberly and Jourdain are not the only people to have experienced a time slip. Albert Einstein and Stephen Hawking thought that time travel was theoretically possible. Apparently, it is possible in Ely. Thus far, Ely is the only part of Nevada where I've heard of a possible time slip. But this doesn't mean it hasn't happened elsewhere in the Silver State.

Because I am a writer of ghostly phenomena, I sometimes receive e-mails from people who have experienced what they think is ghostly or out of the ordinary. Several years ago, a friend told me about her experience in Ely that I was certain was a time slip. Not long after that, a woman e-mailed me with the claim that she had time-slipped while visiting a hotel in Ely. By her description of events, I believe she was staying at the Hotel Nevada:

I'd been on the road most of the day and was so tired and hungry. After freshening up I went down to the restaurant for a bite to eat. As I walked through to the restaurant, everything looked different from the hotel I had checked into not an hour ago. Was I in the wrong hotel, I tried to figure out how that could have happened. There was a party atmosphere; the music was loud and tinny. People laughing and cheering, everyone I saw were dressed in clothing that was outdated by at least sixty years. I found an empty lounge chair and sat down to gather my thoughts. I knew I wasn't seeing things. When a man walked by with a tray of glasses, I asked, "Sir what is going on here?"

He stopped at looked at me as if I'd lost my mind.

"Prohibition has ended," he said.

"That was over sixty years ago!" I said. As soon as I said that everything was quiet and I was back in the hotel lounge.

Much later, I heard from another woman who had experienced a very different time slip (or ghosts) in the desert outside Ely:

I was on the road to Cherry Creek when I saw them on the side of the road. It was a man and a woman who was holding a baby. Their broken down car looked like an antique. I slowed up and pulled over. Driving an old car like that out here in the middle of nowhere isn't very smart with a baby. I was prepared to tell them. As I got closer I noticed their clothes were old fashioned, even her hair was styled like something from a long time ago. Were they on their way to some costumed event?

"No one hardly drives on this road....Lucky I happened along....Hop in and I'll give you a lift?" I said.

But this wasn't the strangest thing. They just looked right past me like they were looking for someone or something.

"You folks lost?" I asked.

She said something to him. I saw her mouth moving but I couldn't hear her words.

"Do you want a ride or not?" I asked

They smiled at each other and stared off into the distance.

"Suit yourself if you'd rather stay out here. But that's not very smart with a baby," I told them and started to walk back to my car. I turned around to see if they had changed their minds and it was like they'd never been there. They were gone...and so was their car. It was hot out there and I felt cold chills. This was the first time I ever considered ghosts or whatever that was.

Most researchers will peg this one as a residual haunting or place memory. Writer Frederic W.H. Myers, one of the founding members of the first Society for Psychical Research, called this type of event a "veridical (or true) haunting."

Big Four Ranch Brothel

With legalized prostitution, gambling and pot, one could easily get the idea that Nevada is an "anything goes" state. Nothing could be further from the truth. Each of these three vices is heavily regulated (and taxed) by the state and the individual county in which it operates.

In Nevada, there's this ranch and that ranch. And a "ranch" is often a euphemism for a brothel—the thinking being that it sounds somehow more acceptable to be going to "the ranch" rather than to "the brothel." Legalized prostitution is part of our state's culture, and as such, it's not seen as strange. In small towns such as Ely, brothels may operate within the city limits, but not within one thousand feet of a school or a church. Big Four Ranch is located on High Street and has been since 1887.

Rumor has it that the area around the brothel is haunted by the ghost of Constable Edwin Gilbert, who was shot and killed nearby on October 12, 1907, by F.M. Saunders. Constable Gilbert had come here to arrest Saunders for beating an Ely prostitute by the name of Ruth Dearborn. As the constable fell to the floor, he fired his gun. A lucky karma-assisted shot for a dying man, the bullet struck its mark, killing Saunders instantly. The constable is said to have spent his last breath telling his men that there was no need to track down his killer—he'd got him.

A shadowy figure has been seen walking, as if in a daze, in the same area many times since that long ago night. It could be the constable. But then again, it could be the killer wondering just what exactly happened.

Hotel Nevada

Lyndon Baines Johnson stayed here at the Hotel Nevada. So did Ingrid Bergman, Mickey Rooney, Hoot Gibson, Jimmy Stewart and Charlie Pride. Author Stephen King stayed here as well. There is a long list of famous people who have slept under this hotel's roof. But let's not forget the infamous. Rumor has it that Arthur "Pretty Boy" Floyd spent some time here at the hotel while on the run from the law. The hotel offers ordinary everyday (but

Above: Hotel Nevada; *Left*:
Sign at Hotel Nevada.
Photos by Bill Oberding.

very small) hotel rooms, and then there are several theme rooms dedicated to the celebrities who have slept here. Among the rooms are the Charlie Pride room, the Mickey Rooney room and the Ingrid Bergman room.

Built at a cost of $400,000, the six-story hotel opened on July 15, 1929, on the edge of the Great Depression and Prohibition. With six floors, the hotel took the title of tallest building in Nevada from Tonopah's Mizpah Hotel. New and sleek, the Hotel Nevada was billed as Nevada's first and only fireproof building. Since its opening, the hotel has seen a succession of owners. But given that it is nearly a century old, that's probably to be expected. It's a quirky place, no doubt. But that makes it all the more interesting, don't you think?

Walk of Fame

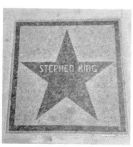

Hollywood has nothing on Ely. Well, in regards to a walk of fame anyway. Ely's Walk of Fame is on the sidewalk at the Hotel Nevada's entrance. The stars represent some of the celebrities who've stayed here at the hotel. Of course, there is a star for Pat Nixon, the Ely girl who grew up to be first lady of the United States, even if she had to marry "Tricky Dick" Nixon in order to accomplish this. Stephen King stayed here; I bet it was while working on *Desperation*. And I stayed here while working on this book. Hmmm…Stephen King is a writer and he has a star. I am a writer and…I wonder if one of these days—never mind.

The stars are impressive: Pat Nixon, Lyndon Johnson, Benny Binion (now there's a name straight out of Las Vegas casino history), Nevada senator Harry Reid, Wayne Newton, Stephen King, Gary Cooper, Ingrid Bergman, Hank Thompson, Charlie Pride and Mickey Rooney. Wow! With all these luminaries, we were feeling pretty good about staying here at the Hotel Nevada.

Top: Walk of Fame; *Bottom*: Stephen King's Star. *Photos by Bill Oberding.*

A Night at the Hotel Nevada

What about those ghosts? A great question I hoped to get answered. As our rented Kia Soul sped down Highway 50 toward Ely and the Hotel Nevada, I let my writer's imagination wander. Does one of the honorees of the theme rooms haunt the place? Does the ghost of old gospel singer Tennessee Ernie Ford wander the hotel's hallways singing "Sixteen Tons"? Just who was haunting Hotel Nevada—if, in fact, the hotel was haunted at all.

We checked into our room and had a laugh at the sign in the bathroom:

Dear Guest,

Please be aware that because of the age of the historic building—built in 1929—the hot and cold water flow may sometimes fluctuate without warning. We hope this is a small inconvenience to pay for what we hope will be a memorable stay.

Thank you.

Not a problem for us. We're used to staying in old buildings with their minor inconveniences. But the ghosts, now that might make our stay memorable, especially if one should come and tell us what slot machine is about to pay off big. But where were they hiding out and haunting? We

Hallway, Hotel Nevada. *Photo by Bill Oberding.*

Hoot Gibson door. *Photo by Bill Oberding.*

asked at the front desk. This is when we discovered that ghosts, ghost hunters and hauntings don't seem to be a popular subject here at the Hotel Nevada. We'd been told by someone that the fifth floor was the most haunted. But a woman at the desk informed us, "They are all over. And we haven't had any activity in over a year."

Clearly, there is absolutely no interest in ghostly things here. They are almost as frightening as the cigarette-fogged casino and the taxidermy stuffed animals that decorate the place—maybe more so.

So, we did some EVP sessions in our non-haunted room. We called out to anyone, "Please, doesn't anyone want to speak to us?" On a hunch, I asked if old-time silent movie star Hoot Gibson was present. After all, he has his own theme room. We received the faintest of laughter. Not enough to brag about. Was it Hoot or not? We couldn't be certain. In that case, any good EVP analyst knows that the recording is tossed. Okay, one more chance. I called out for the "King of Western Swing" music himself, Hank Thompson. Forget about the "Wild Side of Life" and come on over from the hereafter. Are you there, Mr. Thompson? Silence. Clearly, there was no interest in speaking to us from the great beyond. Meanwhile, the marquee lights outside our window were flashing on and off, and the TV of the people in the next room was tuned to a raucous football game. With this sort of luck, I might have been better off taking my chances at a slot machine in the casino downstairs. Such is life in the ghost hunting world.

White Pine County Courthouse and Hank Parrish

Hamilton was the first county seat of White Pine County. After a devastating fire destroyed the Hamilton Courthouse, Ely was given county seat status. Built in 1908 at a cost of just under $50,000, the White Pine County

Above: The White Pine County Courthouse; *Left:* Inside front entrance and stairs of the White Pine County Courthouse. *Photos by Bill Oberding.*

Courthouse was Ely's second courthouse, third for White Pine County. It is rumored to be haunted by the ghost of Hank Parrish.

Hank Parrish was a killer. Although it has never been proven, Helen Stewart believed that Parrish was responsible for the shooting death of her husband, Archibald, in 1884 at the Kiel Ranch. Helen Stewart went on to be very successful in early-day Las Vegas and is considered the first lady of Las Vegas. Hank Parrish continued his murderous rampage. Six years later, on August 2, 1890, he stopped in at a saloon in Royal City, sixteen miles from Pioche, Nevada. Four men were quietly playing poker at one end of the saloon. Parrish ambled up to the table and leaned on P.G. Thomson. When Thomson asked him to stop, Parrish walked away without a word.

After a shot of whiskey, he returned and leaned on Thomson once more. This time, Thomson angrily told him to quit. As Parrish walked back toward the bartender, Thomson and the other men shared a joke. Their laughter infuriated Parrish. He stomped up to Thomson and said, "No son of a bitch is going to laugh at me, you damn cur!"

"I am not a cur!" Thomson spat.

Everyone in the bar knew Parrish and his propensity for violence. They tried to coax him into a friendly drink, hoping to keep him from Thomson. He would not be dissuaded. He pulled out a knife and returned to Thomson. "You are a cur and a son of a bitch," he snarled.

Thomson rose from his chair. "I don't want to fight you," he said. But as he spoke the words, Parrish hit him in the mouth and then violently plunged the knife deep into his abdomen. Thomson died four days later. The people of Pioche were outraged. Thomson had been well liked. Fear of lynching and an unfair trial guaranteed Parrish a change of venue. He would be tried in White Pine County and the courthouse in Ely. Found guilty of murder, Parrish was sentenced to death. His murderous days were over.

On December 13, 1890, Hank Parrish was hanged near the courthouse. They say that he continues to haunt the building. The sounds of boot-shod ghostly footsteps have been heard throughout the halls. There are the uncomfortable feelings of being watched and the cold blast of air that emanates from out of nowhere that are attributed to Hank Parrish.

Nevada Northern Railway Museum

There's an old gallows humor joke about dying at the beginning of one's work shift rather than at the end. Railroad conductor George Haviland

wasn't so lucky. On June 12, 1912, Haviland bid his wife and five children goodbye and went to work at the station in McGill—his routine, as he'd been the conductor for engineer Ed Stewart on the seventeen-mile train trip from McGill to Ely countless times. Everything changed that evening as the train pulled into the Ely railroad yard around six o'clock. Haviland uncoupled the train cars from the engine and tried to make a flying switch, which would have sent the empty cars onto another track. But something went terribly wrong. The first car derailed and was thrown sideways. Haviland attempted to jump out of the cars' way but misjudged which way the cars were twisting. He was crushed in the onslaught of speeding train cars. According to a story in the *Nevada State Journal* from June 16, 1912, "He died a few minutes afterward having been mangled to a frightful extent."

Top: Nevada Northern Railway Museum entrance; *Bottom*: Towers in the railyard where ghostly activity has been reported. *Photos by Bill Oberding.*

The ghostly Haviland has been seen in and around the railroad museum yards many times since the tragic accident that took his life. He is blamed for any strange activity and noises in the museum building. The ghost may also be responsible for the strange activity that takes place at the old coal tower as well. Doors occasionally open and close of their own volition.

Today, the railway museum is dedicated to keeping the history of Nevada's railroads alive. And since the trains are one hundred years old, someone must be trained in the upkeep and repair of them. This is another area that

Top: Outside in the railyard at the Nevada Northern Railway Museum, where the ghostly George Haviland is seen. *Author's collection.*

Bottom: Delivery truck, circa 1929, at the Nevada Northern Railway Museum. *Photo by Bill Oberding.*

Right: Train at Nevada Northern Railway Museum; *Below*: Ceiling of the engine house at the Northern Nevada Railway Museum. Note the steam vents for steam engines in the engine house. *Photos by Bill Oberding.*

the museum focuses on. People come from all across the United States to visit the museum and ride the Ghost Train in October and the Polar Express in December. Other times, you can come and ride either a diesel or a steam train, depending on which one is running that day.

While Bill and I were visiting the engine maintenance repair shop at the railway museum, we met a very informative man who explained the shop's activities and some of its equipment. Suddenly, there was movement—I saw it out of the corner of my eye. Always on the lookout for the paranormal, I wondered if this might be some bit of paranormal activity. It wasn't. Instead, an adorable yellow and white cat had jumped from somewhere in the shop and was making its way toward us. Cats have nine lives.

They must also have a sixth sense about feline aficionados. We called this cat "Shop Kitty." We were informed by Kurt, our guide, that the cat's actual name was "Dirt." Not a very colorful name, but it was apropos. The kitty's white paws had been blackened by oil and soot. Shop Kitty lovingly brushed and twirled around our legs. "Cat people—they're obviously enchanted by me," he seemed to say. Of course we were. So we wondered aloud, "Is Shop Kitty a mouser or is he fed cat food?"

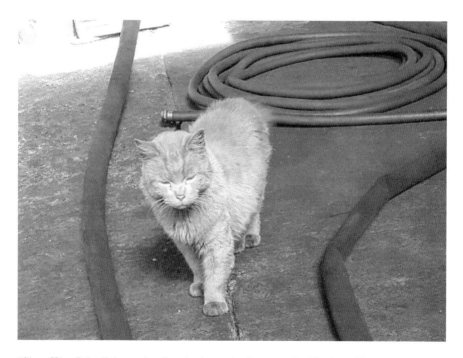

"Shop Kitty," the little cat that lives in the engine house at the Northern Nevada Railway Museum. *Photo by Bill Oberding.*

Kurt said, "We feed and take care of him." Visions of a starving Shop Kitty stalking faster mice faded, and we could now relax and enjoy ourselves. We discovered that the same train is used for the Ghost Train and the Polar Express. If you haven't come here and ridden these trains, you should.

The Chainman Mine

The gray, misty apparitions of Chinese miners who died in a cave in at the Chainman Mine back in the 1870s are said to wander the highway between Ruth and Ely. Their ghosts are reminders of the callousness that led to their tragic deaths. After the cave-in, a manager made a terrible decision. He decided that rather than attempt rescue or recovery, it would be more cost effective to cover over the spot of the cave and forget the unfortunate men. Legend has it that this was done. This is similar to another tale in the Lake Tahoe (Donner Summit) region of Nevada/California.

Another local legend says that the story of the Chainman Mine cave-in was inspiration for Stephen King's novel *Desperation*. I believe it. After all, what writer couldn't find all the inspiration he or she would need right here in Nevada?

Giroux Mine Disaster

Nothing guarantees a haunting like an unexpected death. Although it was well known that mining was a dangerous occupation, no one ever expected that it would happen to them. Fire was one of the worst dangers a man could face while working in the mines. On August 23, 1911, several men were working at the 1,400-foot level of the five compartments at the Giroux Mine. Suddenly, they heard what they thought was an explosion and the shaft was in flames. Some of them jumped in the cage and headed for the surface. At 1,200 feet, a few of the men tried walking toward another shaft and safety. Five men were pulled to the surface. Seven others would die in the mine. Among the dead was John McNulty. The White Pine County, Nevada Coroner's Inquest Book 1910–14 reported that McNulty was "killed in the Giroux Shaft of the Giroux Consolidated Mine Company of Kimberly, NV from a fire at the 1200 level. The inquest jury verdict was placed on file with the county clerk. Unknown what the verdict said as it was not written in this book. McNulty's body was not recovered until February 12, 1912. He either

suffocated or was squeezed to death between the shaft and cage. Giroux Consolidated Mine Company was found to blame for the deaths of him and six others. 7 men killed."

It's said that on certain summer nights, the sound of men screaming in agony can still be heard in the area of this tragic mine disaster. This may be what is commonly referred to as a residual haunting. This can occur when events of strong emotion imprint on a location and replay themselves.

Copper Flat Blast

Another location that may present residual hauntings is Copper Flat, a rail yard near Ely where mine rail cars coming from the Liberty Pit were loaded and switched. The work here was just as dangerous as working in the mines. The year 1912 had barely begun when Rocko Maffeo lost his life. According to the White Pine County, Nevada Coroner's Inquest Book 1910–14, Maffeo "died at Steptoe Hospital from injuries caused by his own carelessness while trying to close a door on a open ore car at Copper Flat."

It was three days past the Fourth of July 1912 when a mine powder explosion killed ten men. "Explosion of powder at Copper Flat. Remains recovered as far as possible. 10 men killed," found the coroner's inquest. Five years would pass before their survivors received compensation for the loss of their loved ones. The sum was $1,500 each.

Loneliest Road Hitchhiker

Just about every location in the United States has at least one ghostly or vanishing hitchhiker. This is usually a female hitchhiker from the hereafter that gladly accepts a ride only to vanish right before the Good Samaritan's startled eyes as the journey continues. Another will disappear just as the kind motorist pulls up to the side of the road. Judging by the amount of these vanishing hitchhikers on America's highways and country lanes, ghosts must like to travel. Some may argue that these are not ghosts at all, but merely urban legends. Either way, the Ely/Ruth area has a vanishing hitchhiker that happens to be a man.

Ely is listed as one of the coldest places in the contiguous United States. When winter comes, it seems to stay forever, and driving is perilous. That stretch of road between Ely and Ruth can be treacherous and difficult to

travel in the winter months, when snow just keeps on falling. A lot of people have lost their lives out on this road, especially when it is slick with ice. Perhaps the phantom hitchhiker was one of these unfortunate folks.

It is always on a freezing-cold night that the man appears, bundled up and looking for a ride. If you happen to be out on such a night, and I really hope that you're not, if you see the phantom hitchhiker, shivering against the icy wind, don't bother stopping for him. If you do, he'll just vanish before your eyes. You're not the ride he's been looking for.

FALLON'S GHOSTS

Fallon proclaims itself to be the "Oasis of Nevada." Rich in lush farmland, Fallon farmers produce some tasty cantaloupes known as Hearts-O-Gold. There's a small-town charm with a big-city feel here, especially when compared to the smaller towns along Highway 50.

Fallon Naval Air Station

The navy trains its pilots at the Fallon Naval Air Station. It is on 240,000 acres located southeast of the city of Fallon and has been the home of Top Gun Naval Fighter Weapon School since 1996. During training maneuvers, some pilots have been killed. One of them is believed to haunt the base. Witnesses have seen him several times roaming around the second floor of the deck room.

There are other locations with ghostly activity. There is talk that the weapons department is haunted by a gunners mate. I asked a friend about this. He was stationed at the naval base and since retired. "Why wouldn't it be haunted?" he asked. "There are a lot of weird things that go on at the base, you know." No I don't. But he is a trusted friend, so I'll take his word for it.

He continued:

> *People know about the ghosts. And some of them talk about what they've seen. If you come in through the front gate and go over to the left where the officers eat, that's where a lot of shadowy type figures of officers have been seen. They're dressed in 1940s flight gear, and they are running around like*

they are getting ready to go out on a mission or something. Security guards at the brand-new Top Gun Building way out toward the back say there's a lot of stuff going on there. One of the fighter jets crashed in that area. They say they think he might be one of the officers who died in the crash.

Douglas Mansion

Known as the "Pink House" for the lovely shade of pink it is painted today, the Douglas Mansion was built in 1904 by Robert L. Douglas, who came to Fallon in 1904, when the town became the county seat of Churchill County. Easily the most lavish house in Fallon, the Queen Anne–style house was home to the Douglas family until tragedy struck when Mrs. Douglas's twelve-year-old brother died in the house. The pain was unbearable. The Douglas family moved to their Island Ranch home, and the house was sold to Dr. F.E. Nichols, who would convert the garage to the Cottage Hospital, which was a hospital for women. This is probably where the story about abortions being performed here came from.

Douglas Mansion, also known as the "Pink House." *Photo by Bill Oberding.*

Anyone driving down Maine Street in Fallon can't help but notice the eye-catching pink house on the corner of Carson and Maine Streets. The house is listed in the National Register of Historic Places and today is used by the City of Fallon as offices. Several years ago, I was told of a woman in early 1900s attire who was spotted at one of the upstairs windows late in the evening. Was she Mrs. Douglas or the spouse of Dr. Nichols? Or was she someone else altogether different? I've never forgotten my friend's excitement as he told me about the ghost he'd seen at the window. He'd circled the block and taken photos of the window. Try as I might, I saw nothing in the grainy photos he showed me. Maybe it was somebody who lived there or was working there. That's what I told myself, and I let it go. Still, I wonder if the Pink House is haunted.

That Other Overland Hotel

If there's one thing Nevada isn't lacking, it's an Overland Hotel. There was an Overland Hotel in Reno, until it was torn down to make way for a parking garage. There's an Overland Restaurant and Pub in Gardnerville, but the two that people seem to get confused are the Overland Hotel in Pioche and the other Overland Hotel here in Fallon. Rumors have been flying ever since Zak Bagans' *Ghost Adventures* visited the Pioche Overland Hotel. It was haunted, apparently not by someone very nice, Zak always seems to encounter this sort, doesn't he?

The Overland Hotel in Fallon was built in 1908 and is listed in the Nevada Register of Historical Places. The old hotel was recently remodeled and redecorated. It's not the Montage Beverly Hills, but it is Nevada, and if you're asking, I'm betting it's haunted. Of course, we won't know this for sure until Zak Bagans' *Ghost Adventures* makes its way to Fallon and the other Overland Hotel.

EPILOGUE

There was an old song about love being wherever you found it. Ghosts are a lot like that, they're there where you find them. And there are no guarantees that you will find one. It's something like the lottery, you can play all you want…winning is another matter.

If there is one thing I've learned in my quest for ghosts it's to stay open minded and to enjoy the adventure. Wherever it may take us, I know that Bill and I will meet interesting people, discover fascinating history and see

Desert along the Loneliest Highway. *Photo by Bill Oberding*

breathtaking natural scenery as well as some incredible manmade sites. If, and I should stress if, we are not so blinded in seeking so-called evidence that we are oblivious to the people and the things that are all around us. Life is too short for that. We only need to look around at the old buildings that have survived their creators by a century or more to understand this.

I have truly enjoyed the time Bill and I have spent on our Loneliest Road adventures. If I have piqued your interest in exploring this wondrous region of Nevada, I have succeeded. By reading my book you have shared the journey with me. And for that I am grateful. Thank you!

BIBLIOGRAPHY

Angel, Myron, ed., with adv. ed. Ray A. Billington. *History of Nevada: The Far Western Frontier*. New York: Arno Press, 1973.

Basset, Mark S., and J. Joan. *Nevada Northern Railway*. Charleston, SC: Arcadia Publishing, 2011.

Hall, Shawn R. *Romancing Nevada's Past: Ghost Towns and Historic Sites of Eureka, Lander, and White Pine Counties*. Reno: University of Nevada Press, 1994.

Hopkins, Winnemucca Sarah. *Life Among the Piutes*. New York: G.P Putnam's Sons, 1883.

James, Ronald M. *County Courthouses of Nevada Temples of Justice*. Reno: University of Nevada Press, 1994.

James, Ronald M., and Harvey Elizabeth Stafford. *Nevada's Historic Buildings*. Reno: University of Nevada Press, 2009.

Kappele, William A. *Rockhounding Nevada: A Guide to the State's Best Rockhounding Sites*. Falxon Guides, 2nd ed. Guilford, CT: Globe Pequot, 2011.

Lewis, Oscar. *The Town that Died Laughing: The Story of Austin, Nevada's Rambunctious Early Day Mining Camp and Its Renowned Newspaper the Reese River Reveille*. New York: Little, Brown, 1955.

Lingenfelter, Richard E., and Karen Rix Gash. *Newspapers of Nevada: A History and Bibliography, 1854–1979*. Reno: University of Nevada Press, 1984.

Manno, Silvio. *Charcoal and Blood: Italian Immigrants in Eureka, Nevada, and the Fish Creek Massacre*. Reno: University of Nevada Press, 2016.

Moberly, C.A., and Eleanor F. Jourdain. *An Adventure*. London: MacMillan and Company Limited, 1913.

Oesterle, Joe, and Tim Cridland. *Weird Las Vegas and Nevada.* Edison, NJ: Sterling Publishing Company, 2007.

Patterson, Edna B., Louise A. Ulph and Victor Goodwin. *Nevada's Northeast Frontier.* Reno: University of Nevada Press Reno, 1991.

Sturtevant, William S. *The Native Americans: The Indigenous People of North America.* London: Salamander Books, 1991.

Newspapers

Daily Nevada Journal. August 16, 1883.

Daily Reese River Reveille. October 31, 1868, and December 14, 1881.

Eureka Daily Sentinel. November 11, 1880.

Eureka Leader. January 9, 1879.

Nevada State Journal. March 19, 1922.

Pioche Daily Record. September 4, 1876.

Reno Gazette Journal. April 10, 1994, and July 11, 1999.

Seymour Weekly Times. June 30, 1877.

Staunton Spectator. December 20, 1881.

Magazines

LIFE. "The Loneliest Road." July 1986.

Road and Track. "The Loneliest Ferrari." June 2017.

Pamphlet

Nevada Tales from the Past. White Pine Chamber of Commerce, June 1964.

ABOUT THE AUTHOR

Photo by Bill Oberding.

Independent historian and true crime buff Janice Oberding lives in Reno, Nevada, with her husband and two cats. She enjoys travel, photography, reading and digging up little-known Nevada history facts, especially those that involve true crime, the weird and the unusual.